IPSWICH
THROUGH TIME

Caleb Howgego

AMBERLEY PUBLISHING

Acknowledgements

There is not enough space here to thank everyone who has helped me with this book and I apologise for not being able to do so.

My sincere thanks to God, my family and friends for their support and encouragement throughout my work on this book, particularly to those who have proofread parts of it.

My uncle, Richard Davies, has been a brilliant source of advice and help with taking the contemporary photographs.

Many thanks to Suffolk Record Office, Ipswich Transport Museum and Colchester and Ipswich Museums Service, who provided images from the collections of Ipswich Borough Council; many staff from these institutions were incredibly helpful during this project. Especial thanks to them for the permission to include so many of the Victorian/Edwardian images featured here. Brian Dyes has gone out of his way to help with images and answers to questions I couldn't find in books!

I have also obtained photographs from the Ipswich Mayor's Office, Willis, Mike Kwasniak and New Wolsey Theatre, Helen Jones and David Kindred, who I would like to thank here. The computer-generated image of St Mary-at-the-Quay is used with kind permission of the Churches Conservation Trust and copyright Molyneux Kerr Architects.

I have made every attempt to identify and contact the copyright owner for all the images featured in this publication.

Dedicated to my grandparents,
Peter and Nancy Howgego, and Harry and Pauline Davies

First published 2015

Amberley Publishing
The Hill, Stroud,
Gloucestershire, GL5 4EP
www.amberley-books.com

Copyright © Caleb Howgego, 2015

The right of Caleb Howgego to be identified as the Author of this work has been asserted in accordance with the Copyrights, Designs and Patents Act 1988.

ISBN 978 1 4456 3631 3 (print)
ISBN 978 1 4456 3659 7 (ebook)

British Library Cataloguing in Publication Data.
A catalogue record for this book is available from the British Library.

Typesetting and Origination by Amberley Publishing.
Printed in Great Britain.

Introduction

The impulse to compare the past and the present through photographs is not a new one, even on a local level. As far back as the latter half of the nineteenth century, William Vick was doing much the same thing in Ipswich. Vick took over the business and acquired the negatives of another photographic artist, William Cobb, around 1870. By 1890, Vick was publishing copies of his newly captured photographs and accompanying notes, along with mid-century photographs taken by Cobb, in photograph-books called *Ipswich Past and Present*. Some of these volumes still exist today, and many of the Victorian photographs featured in *Ipswich Through Time* are taken from this source.

Ipswich is a town with one of the longest histories of continued human habitation in England. Settlement in the area dates back to at least the fifth century when the site would have been known as Gipeswic (or a similar variant). Where this name came from is a matter for conjecture. One of the more romantic, and arguably more dubious, theories is that the town was named for its founder – Gipp, Gipe or Gippa. It is suggested that this eponymous figure turned up at the banks of the River Orwell fresh from his travels and decided it looked like a good place to set up a market. In Gippa's time it was common for people to be named for a prominent characteristic they possessed, and as 'Gipian' is the Old English verb to yawn, some have made the leap to suggest that Gippa was excessively prone to yawning. According to this theory, it follows that a rough translation of Gipeswic into modern English is 'Yawnsville'. Ipswich may still be struggling with the charge that 'not much happens there', but in truth, some truly interesting things have happened in the town over the centuries. Did you now, for example, that Ipswich was responsible for building the first railroad and locomotives in China? Or that it gained a royal charter securing rights for the townspeople of Ipswich fifteen years before the Magna Carta was signed?

Historically, Ipswich has never been shy to redevelop and reinvent itself, so much so that it has lost a good deal of its ancient character and cultural heritage to the developer's bulldozer. This lack of sentimentality may cause lamentation among some, but the long-held spirit of embracing change is really as much a part of the heritage of Ipswich as any building may be said to be. The reason for all this appears to be rather simple: Ipswich is an ancient town that has undergone a series of long spells of prosperity and decline. Whenever the town was in prosperity, those who could make their mark on the town did – often at the expense of older constructions. To us this can seem an irritation, but also a blessing. How many towns have Grade I listed buildings from 1700 and 1975 that stand side by side? Ipswich does, in the form of the Unitarian Meeting House and the Willis Corroon building respectively.

This book deals mostly with Ipswich's recent history – how the town has changed over the past 150 years or so – although, where space allows it, nuggets of Ipswich's more ancient history have been included.

A temptation with books such as this is to view the past through rose-tinted glasses, and to equate change with decline. It is perhaps telling that Vick's volumes of *Ipswich Past and Present* partly owed their popularity to people wanting to see the town as it used to be, before recent Victorian developments that they saw as degradation. We, in turn, often view the replacement of many of these Victorian 'improvements' with more recent attempts at modernisation as further degradation of what once made the town great. Nostalgia, it seems, never is what it used to be.

It is less common to find scenes of poverty and poor examples of architecture when browsing through collections of Victorian photographs, especially ones that were published or used on postcards. However, these things certainly existed in nineteenth-century Ipswich. We view the town as the few photographic enthusiasts of the time wished to capture it. Likewise, the following ninety comparisons included in this book barely touch the surface of Ipswich as a whole; the sprawling suburbs hardly feature and there are many more interesting buildings and streets that, due to space limitations, have not been included.

The Ipswich of the Victorian era was an ever-changing place. Significant developments were being made in the docklands and new civic and private buildings of interest were popping up all over the growing town, often replacing more ancient features. Ipswich may have lacked the abundance of natural resources that fuelled the Industrial Revolution in other parts of the country, but what the town lacked in this respect it made up for with entrepreneurial ambitions. The town was host to Ransomes, the agricultural machinery manufactures, and the Cobbold Brewery, both of which were nationally important. During this period a huge population shift was taking place across the country as people from rural communities increasingly moved to towns and cities. Being the main urban centre in Suffolk, Ipswich's population soared, rising from 25,384 in 1841 to 57,360 in 1891. Some of the many new constructions of this era, which served the growing community, included: the post office on Cornhill, the current Town Hall, the original and current museum buildings on Museum Street and High Street respectively, the Grammar School on Henley Road, the railway station and the Corn Exchange, not to mention new railway services including a line to Felixstowe and tram lines that connected the centre of Ipswich to the suburbs. It truly was an industrious time.

Today, the population of Ipswich has risen to over 133,000 and the suburbs have expanded out from the town centre to accommodate this. In recent years, the biggest changes have taken place around the Wet Dock, with many of the derelict industrial buildings along the waterfront being replaced with modern apartment blocks and buildings associated with the newly established University Campus Suffolk, bringing a student population to the town. Financial services are now a dominant employer, with around a quarter of the workforce engaged in this sector for employers such as Willis and AXA. The BT Research Laboratories on the eastern fringe of the town are also a big employer. In terms of important future developments, Ipswich Borough Council currently plans to implement a multi-million pound redevelopment of Cornhill. They also aim to redevelop Ipswich Museum into a heritage and arts campus, to form a new cultural hub for the town.

With all that said, let us begin to dive into a photographic comparison of Ipswich's past and present.

Caleb Howgego
November 2014

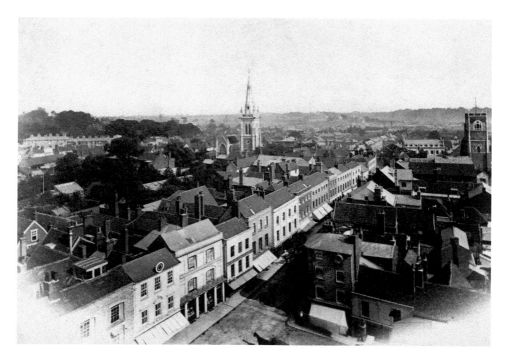

View from the Top of the Town Hall

This east-facing view from the top of the town hall shows the extent of change that has taken place in Ipswich from the 1890s to the present day. The tower of St Lawrence church and the spire of St Mary-le-Tower are still the prevailing features, but it is quickly clear to see just how much redevelopment has been undertaken.

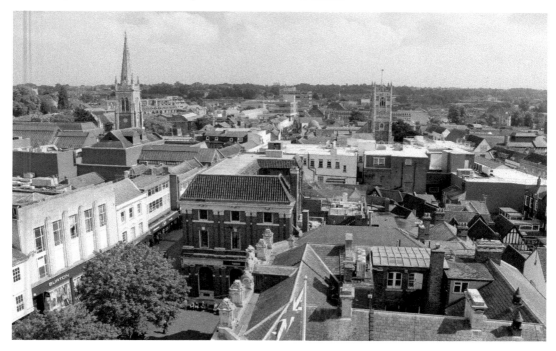

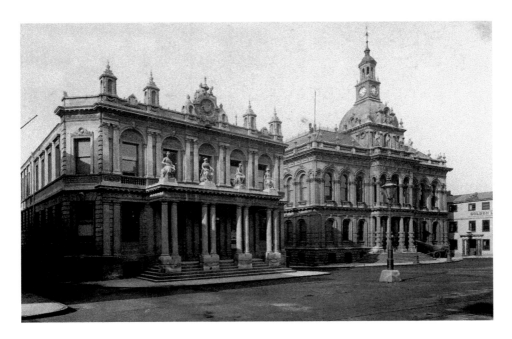

Cornhill

The name of this historic central space in Ipswich goes back to at least the 1600s. Successive generations have continued to rebuild Cornhill, so it is now hard to recognise how ancient it is. The oldest recorded building on this site was a church named St Mildred's, which stood around the site of the present town hall from around AD 700. The two oldest buildings that remain today are the public houses called Mannings and the Golden Lion Hotel, which date back to at least the eighteenth century.

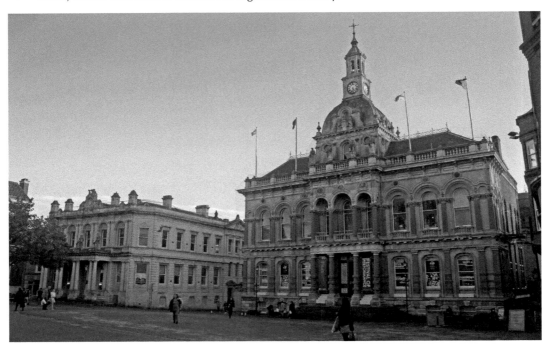

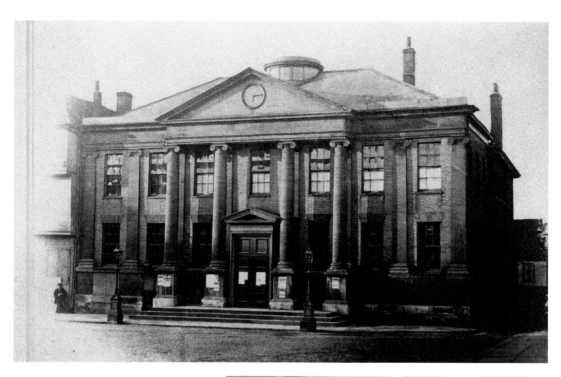

Town Hall

The current town hall was built in 1866/67 in the Venetian style. It housed much of civic life for a century, but in the 1960s, due to lack of space, various borough council departments began to move out. Today, most civic administration takes place in other offices, such as Grafton House. The town hall still plays a municipal role in Ipswich – housing the mayor's office. The previous town hall, pictured above, was demolished in 1865.

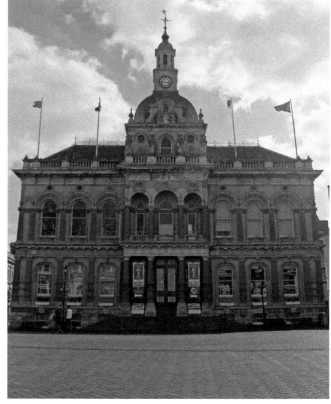

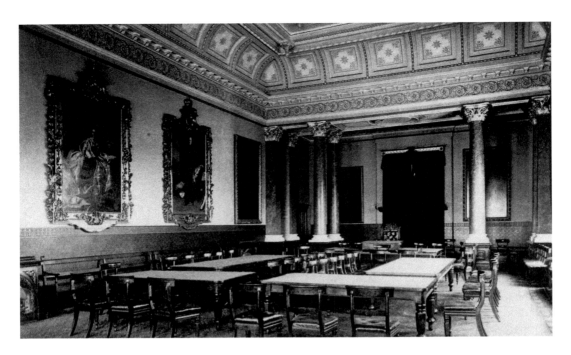

Council Chamber

The town hall once housed the Corporation fire engine, a police station with seven cells in the basement and a library. Here we see another of its rooms, the council chamber. The ornate décor of the chamber has clearly been adapted to something a little more practical in modern times, but the council chamber is still used as the meeting place of Ipswich Borough Council and it can also be hired out for events.

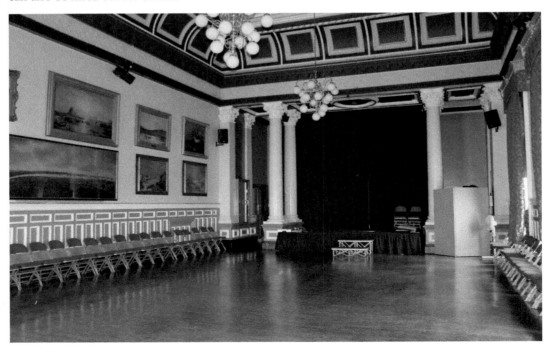

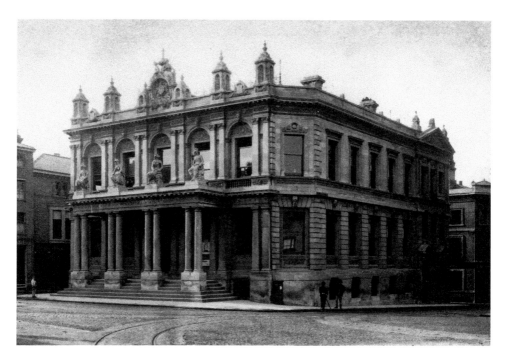

The Post Office on Cornhill

In 1881, as part of a wide-ranging attempt to revitalise a growing Victorian Ipswich, this new enlarged post office was opened. Atop the upper frontage of the building sit four female figures that represent important pillars of a Victorian economic vision: industry, electricity, steam and commerce. Although this building is no longer used as a post office, the four figures have remained intact.

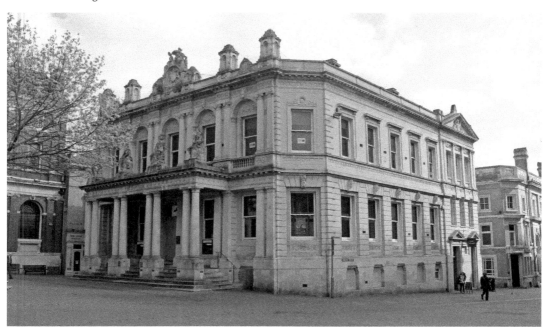

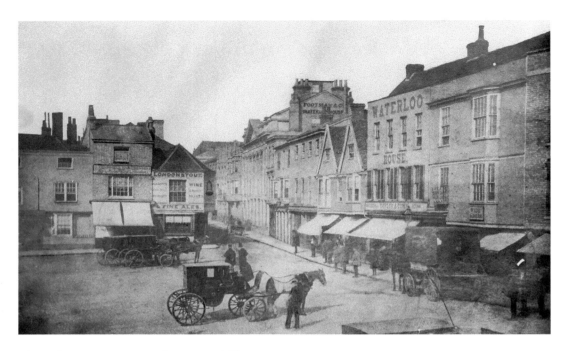

View of Westgate Street from Cornhill

The linen drapers and silk merchant business of Footman, Pretty and Nicholson was set up in 1815, just three days after the Battle of Waterloo. The business opened new premises on Westgate Street called Waterloo House in 1842. A public house selling 'London Stout' and 'fine ales' can be seen in this mid-nineteenth-century photograph, which would later be converted into part of Grimwade's, a well-known outfitters in Ipswich. Grimwade's finally closed in 1996, and since then the building has been occupied by various retailers.

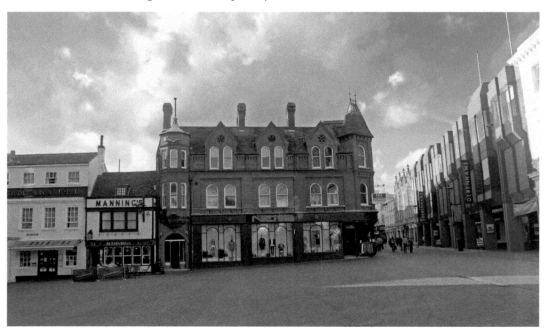

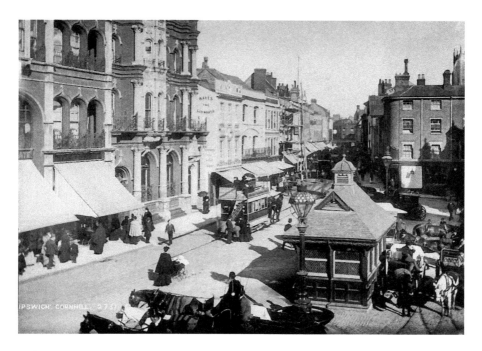

Cabmen's Shelter

This photograph of the Cornhill includes the cabman's shelter that opened in January 1893. It was said that during bad weather the cabmen lurked inside ignoring their customers. As a result, only two years later in May 1895, it was transported to Christchurch Park for the use of the public. It was the victim of arson in recent years, but has been restored and still stands at the eastern edge of the park.

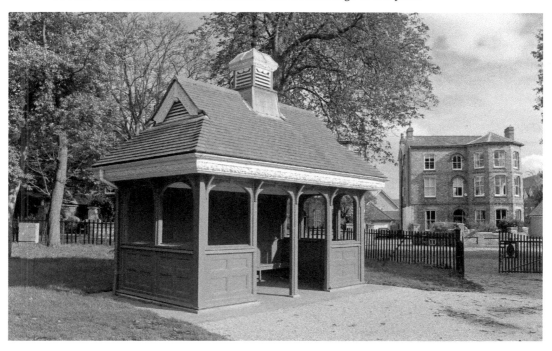

Corner of Carr Street in 1888

Carr Street in many ways typifies the readiness of Ipswichians to continually rebuild their town and their historic lack of sentimentality to retain the town's ancient heritage. As early as the seventh century, 'Ipswich Ware' pottery was being made on this site and exported as far as Kent and Yorkshire. Walking down the street today, it is hard to spot many buildings that predate even the twentieth century.

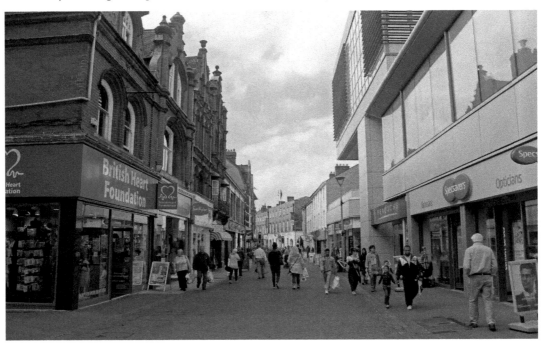

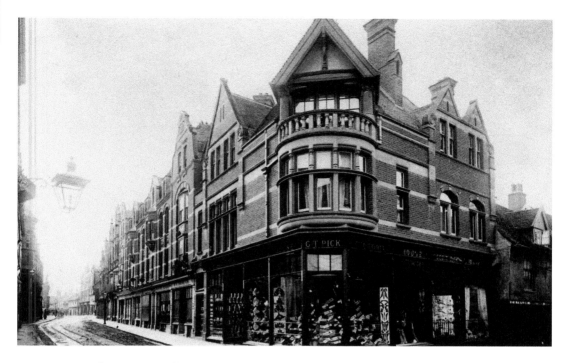

Corner of Carr Street in 1890

This photograph of the same corner featured in the previous Victorian photograph was taken just two years later in 1890. A careful examination of the images reveals the owner of both corner buildings to be G. T. Pick, who ran a draper's shop called Victoria House. Since that time this building, at the junction between Carr Street and Upper Brook Street, has exchanged hands and brands many times, but the structure itself remains little altered since its construction.

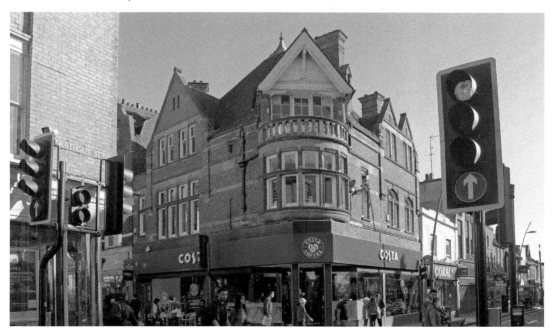

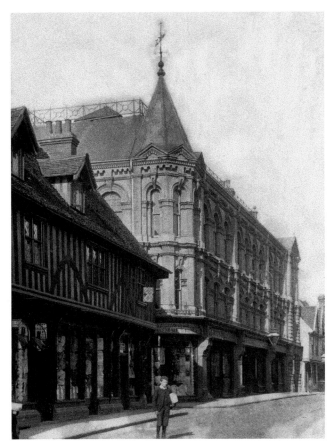

Co-operative Building, Carr Street

The Co-operative Society has a long and significant history in Ipswich and a long standing presence in Carr Street. This building was constructed in 1885/86. The society has done much to help preserve heritage in the town – they launched a blue plaque scheme to commemorate prominent people with connections to Ipswich, and in 1968 helped defeat the proposal to demolish the nearby Great White Horse. The building now plays host to a branch of Bright House, a rent-to-own retail chain.

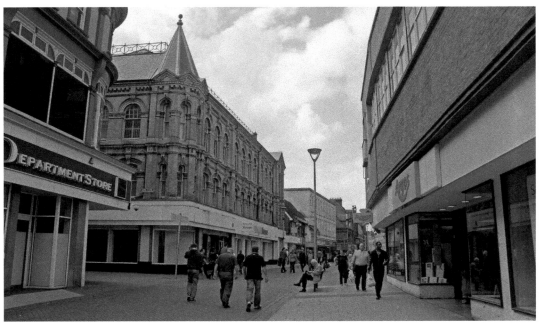

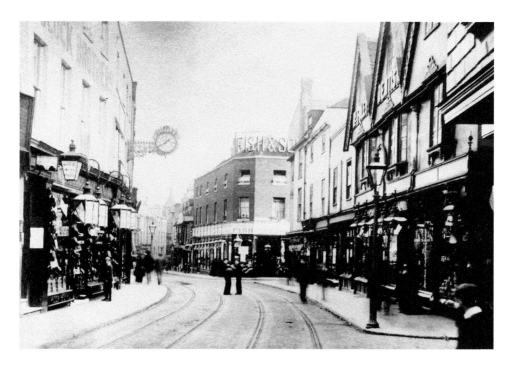

Tavern Street

From the eighteenth to mid-twentieth century, Tavern Street was filled with alehouses, wine shops and inns, thus gaining its name. The street has for centuries been a site of revelry and repose for the people of Ipswich. Geoffrey Chaucer's family were selling wines on this street over 700 years ago. In modern times, Tavern Street has become pedestrianised, and its ale houses have mostly given way to shops and cafés.

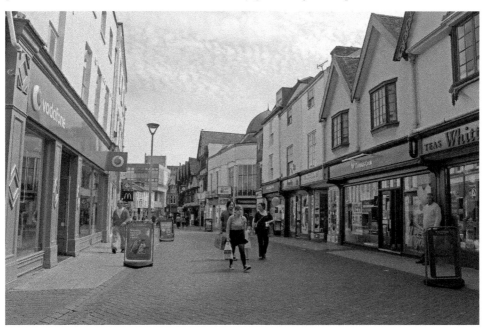

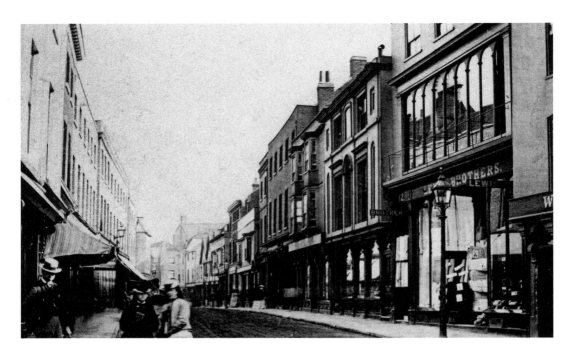

View of Tavern Street from Near Cornhill

Tavern Street has been more than the town's historic home of alcohol over the past few centuries. In the 1700s it was the site of an assembly house, and the Ipswich Institute has inhabited a building in the street since 1834. The *Suffolk Chronicle*, founded in 1810, was also printed and published on this street. One of the most obvious changes, seen here on one of Ipswich's main shopping streets, is the emergence and dominance of the chain store, with well-known brands and logos now adorning most shopfronts.

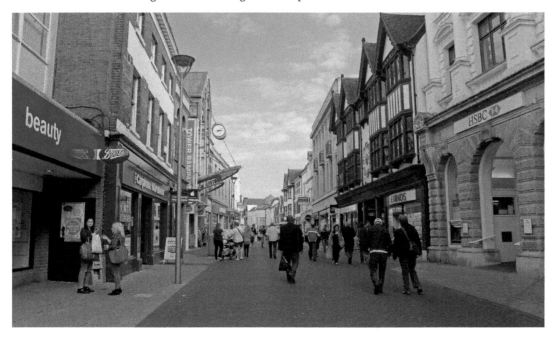

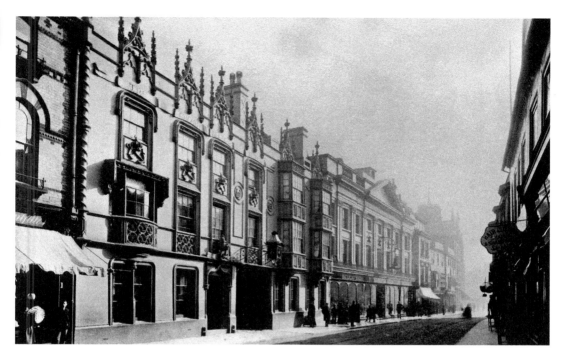

Westgate Street

The Crown and Anchor Hotel, with its admirably ornamented front, was considered one of the town's finest hotels in the nineteenth century, but now is a branch of WHSmith. In the past it stood next to Waterloo House, a linen drapers and silk dealers run by Footman, Pretty & Co. However, by the beginning of the 1980s, the store was taken over by a national chain and, after extensive rebuilding, the store reopened as a branch of Debenhams.

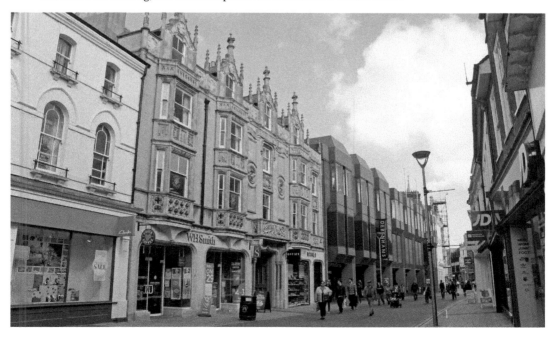

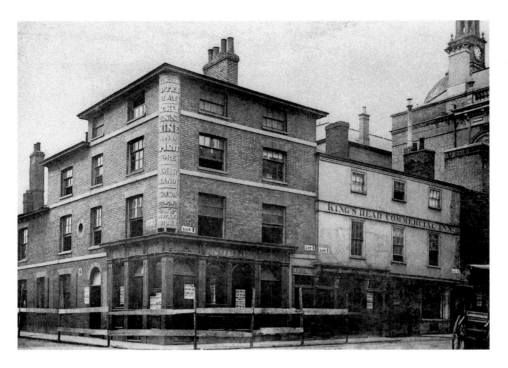

King Street

Once The Sickle Inn and The King's Head, this part of the town centre was considerably altered in the 1870s when these buildings were torn down to make room for the creation of the new Corn Exchange on the site. At the same time, the street names were changed so that the King Street shown in the photograph above became part of today's Princes Street. Now, the only fixed point of reference in the two photographs is the clock tower of the town hall.

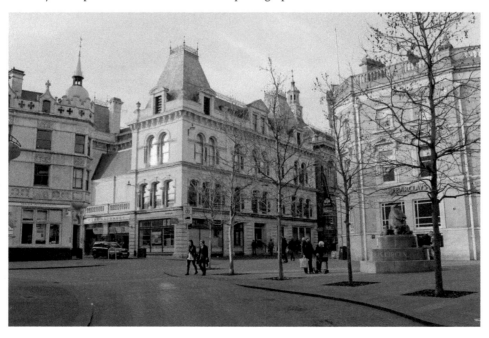

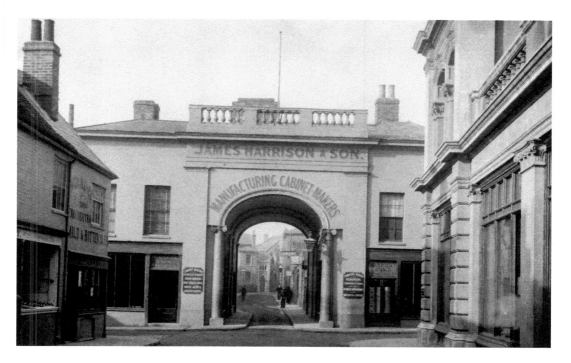

King Street and Arcade Street

Arcade Street was built in the 1840s to better connect Museum Street with the town centre, here cutting through what was then the offices of the Ipswich and Suffolk Banking Company. This is also where the author Jean Ingelow once lived during her childhood, her father being the manager of the aforementioned bank. Beyond the archway is Birketts Solicitors, used by Wallis Simpson during her divorce hearing at Ipswich Assizes in 1936, which eventually led to the abdication of Edward VIII.

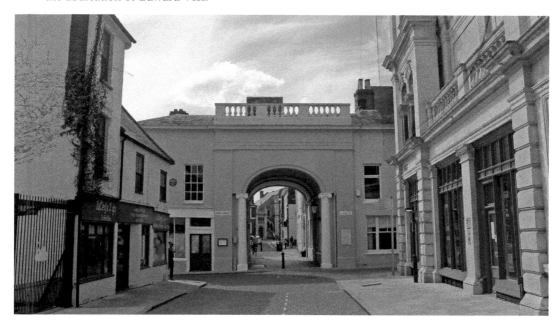

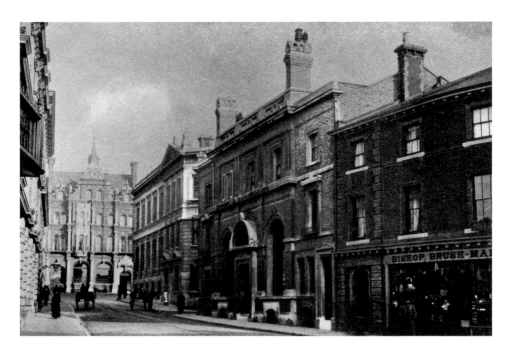

King Street and Cornhill

This road has now been incorporated into the more extensive Princes Street leading from Cornhill all the way to the train station. Much of the Victorian architecture, captured here by William Vick in the 1890s, still survives, although now in most cases it has been put to new use. Part of the Corn Exchange is now used as the independent cinema, Ipswich Film Theatre. An entrance to The Wharf – a gift shop – can be seen in what was once the town's post office on Cornhill.

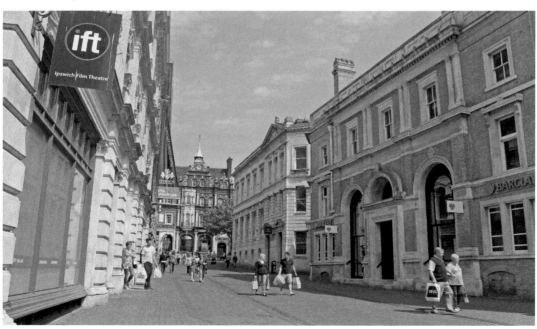

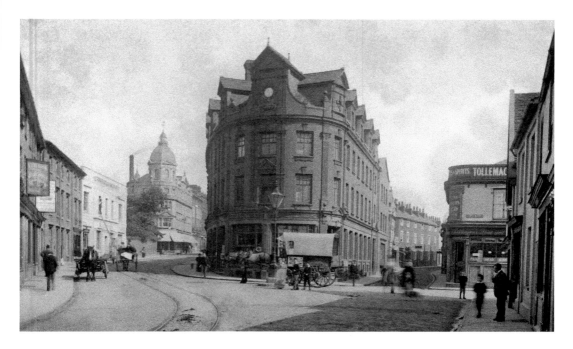

Princes Street and Friars Street

This part of the town has seen considerable changes over the past century. By the 1970s, the space was earmarked as a business centre, and by 1975, the most influential building Ipswich has produced in recent times was completed – the black glass edifice of the Willis Corroon Building, considered a pioneering piece of social architecture complete with a roof garden, gymnasium and originally an Olympic-sized swimming pool. Since 1991, it has been one of the country's youngest Grade I listed buildings.

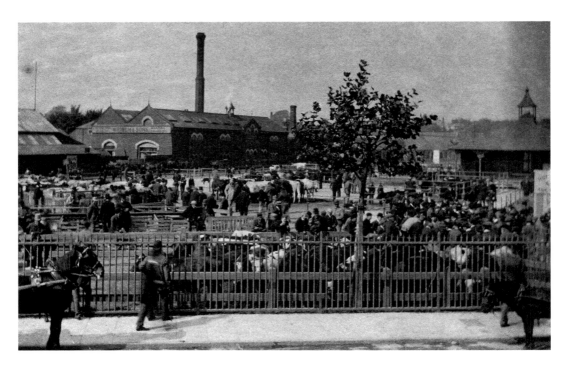

Cattle Market

From 1856, cattle were herded from the town centre along Princes Street to this area that now backs onto Portman Road Stadium. Market days were held on Tuesdays and were a hive of activity with hundreds of people meeting to buy and sell cattle. The market was still running in post-Second World War Ipswich. Today, this site is used as a car park – people still meet here in large numbers, but nowadays on their way to Ipswich Town Football Club matches.

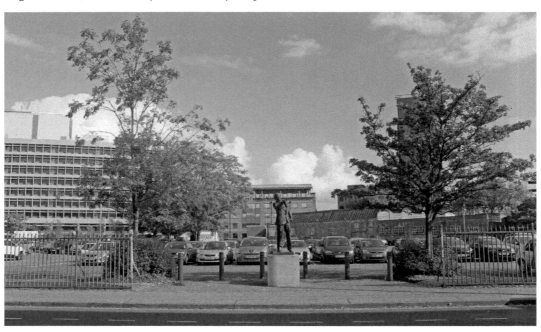

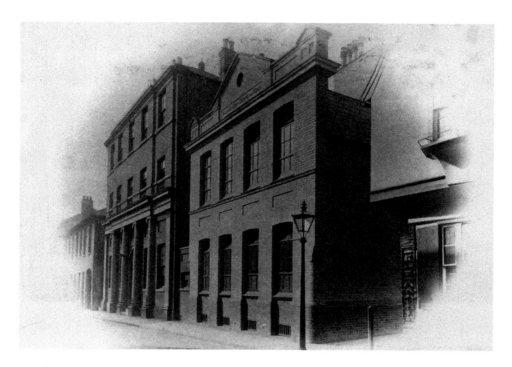

Northgate Street

The exteriors of the buildings on Northgate Street have remained largely unaltered since Victorian times. Inside, however, the buildings have adapted to perform different functions over time. The three-storey building was built in 1821 and was initially used as the town's assembly rooms. Since then it has been used as a girl's school, a motor engineering works, a dry cleaners and, most recently, as a night club.

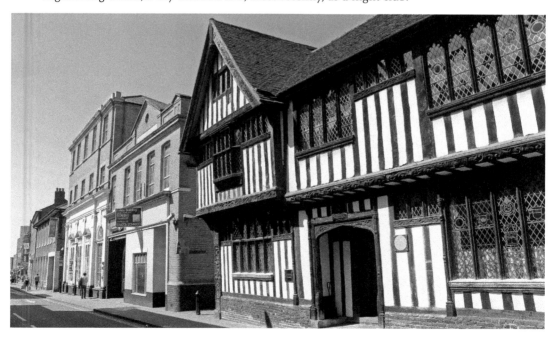

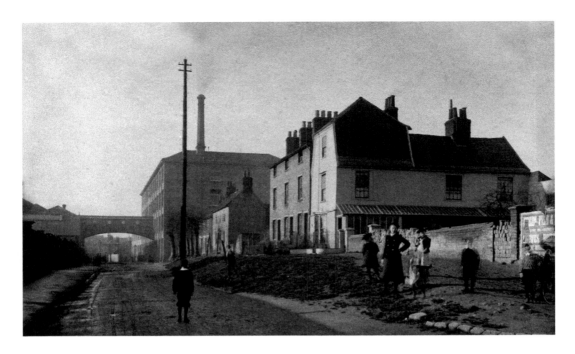

Tower Ramparts

This ancient name refers to the fortifications that protected the town here from at least the twelfth century. All of Ipswich's encircling ramparts are now gone, the last remnants being cleared away in the 1950s. Most of the buildings that William Vick photographed here in 1890 have been demolished. The photograph below shows what most people now think of as Tower Ramparts, the shopping centre that was opened in 1986 on the site of what had been the Tower Ramparts School. The newly renovated Ipswich bus station is also on this site.

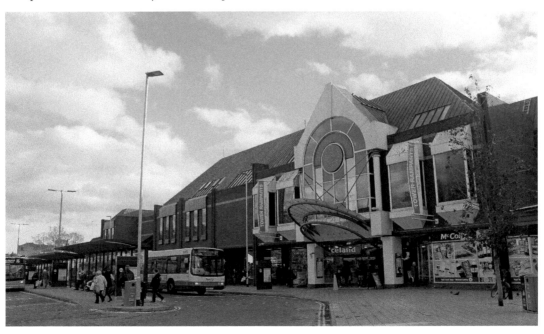

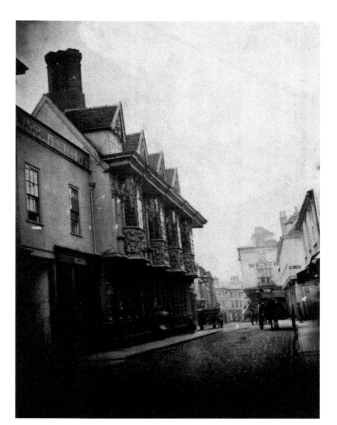

Butter Market

This is another ancient part of the town. A market existed here in one form or another from at least Anglo-Saxon times up until 1810. Fish, meat and dairy products, including butter, were sold along this marketplace on stalls outside of buildings such as the Ancient House, which still stands on this street. This former market remains a place of trade as one of the town's main shopping streets.

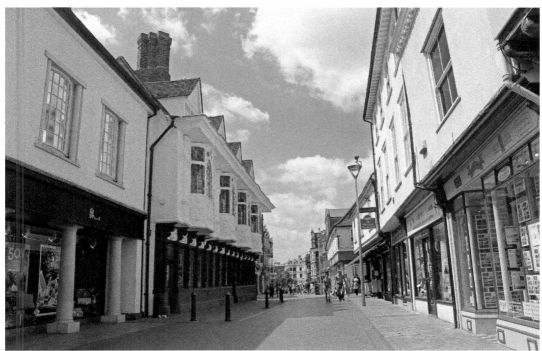

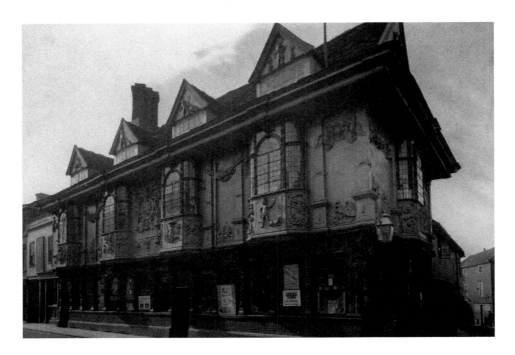

Ancient House

This building's history, as the name suggests, goes back a long way, at least to the second half of the 1400s. The seventeenth-century pargeted front is one of the finest examples of the technique on a building in England. It depicts the world's four then known continents: Africa, America, Asia and Europe (Australia was not yet known to England). It has been used as a place of business by fishmongers, booksellers and printers. Today, Ancient House is a Grade I listed building and is home to a branch of Lakeland (a kitchenware store).

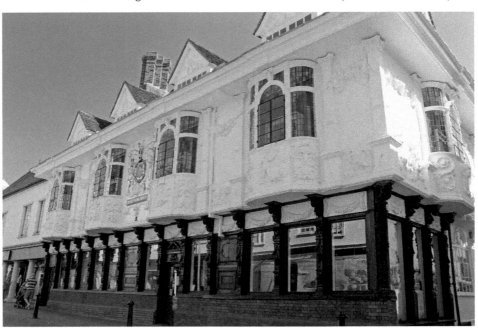

St Stephen's Lane and Dial Lane

The ancient St Stephen's Lane, together with Dial Lane and Tower Street, form a line of three medieval churches – St Stephen's, St Lawrence and St Mary-le-Tower – within approximately 300 metres of each other. It is thought that Dial Lane is named after the clock that projected out from the tower of St Lawrence church. In medieval times, Dial Lane would have been packed with people selling food, and was known as 'Cooks Row' as far back as the second half of the seventeenth century.

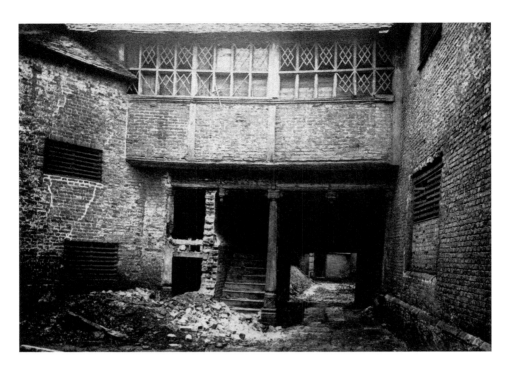

White Friars

This photograph shows the state of ruin White Friars had been reduced to by the end of the nineteenth century. In former times, the site had a more imposing presence in the town. At its height, the Carmelite friary, established in 1278/79, covered a large area from the Buttermarket to Falcon Street north to south, and from Queens Street to St Stephen's Lane east to west. Today, the Buttermarket shopping centre, opened in the 1990s, covers much of what was the White Friars site.

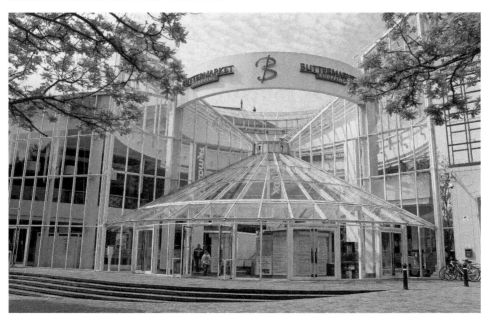

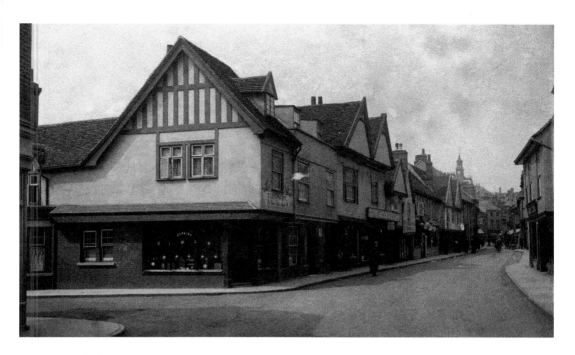

St Nicholas Street

This street takes its name from the nearby medieval church of the same name. Undoubtedly one of Ipswich's prettier streets in the town centre, most of the buildings remain relatively venerable, not having been swept away in the town's many attempts at urban renewal. A recent addition is the statue in the foreground, dedicated to the memory of Russian-born Prince Alexander Obolensky, who played rugby for England and was buried in Ipswich. A careful study reveals the clock tower of the town hall in the distance in both photographs.

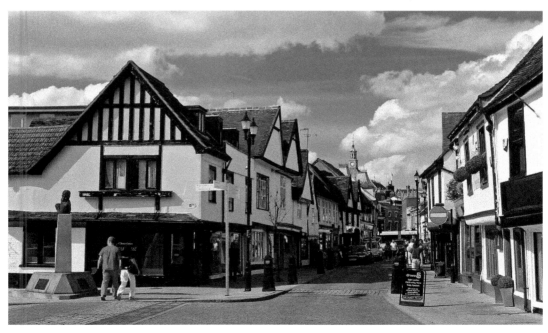

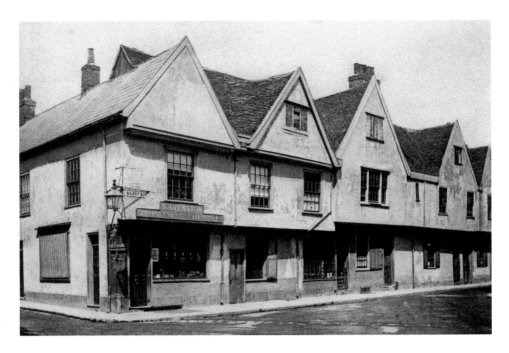

Silent Street

This spot is well known in Ipswich as the suggested birthplace and childhood home of Thomas Wolsey. The distinctive name of the street may have been bestowed for its heavy loss of life during the outbreak of the plague of 1665/66. Another suggestion is that the road was lined with straw to reduce the noise of carts en route to a hospital based on the street in the mid-seventeenth century. Whatever the truth, it remains home to some of the most attractive timber-framed buildings in the town.

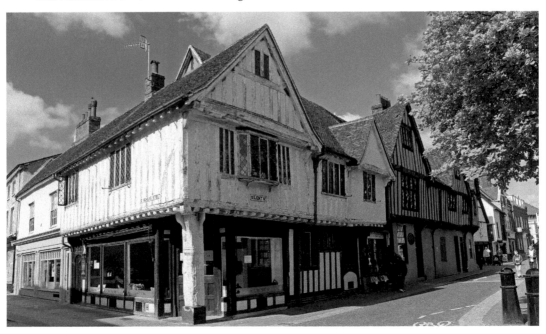

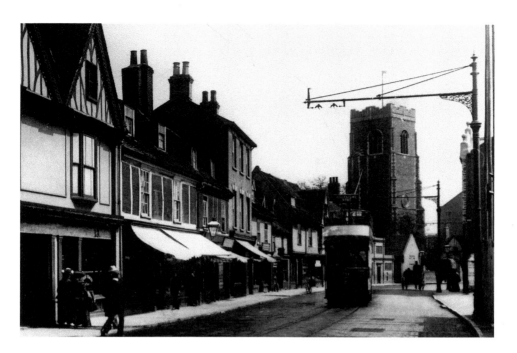

St Peter's Street

Originally, St Peter's Street ran all the way from St Nicholas Street and past St Peter's church. The road is a good deal shorter now due to the Star Lane traffic scheme, which cut off its southern end. The names of the shops and cafés along this pleasant street may have changed over the years, but many of the buildings themselves remain more or less intact. In the background, the tower of The Mill can be seen – an indication of the extensive redevelopment of the nearby waterfront.

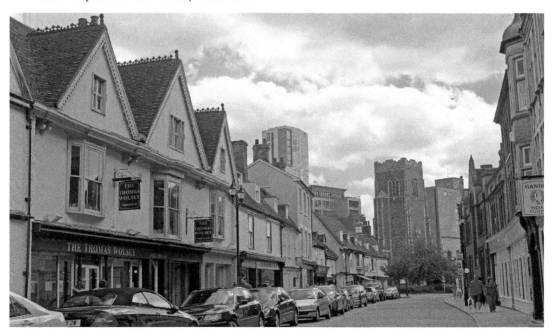

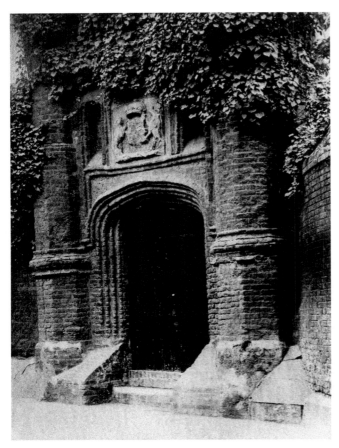

Wolsey's Gate

This is the last remaining fragment of the grand Tudor college planned by Cardinal Wolsey at the height of his power in the 1520s. At this time, Wolsey was the most influential man in England, aside from the king. He founded Cardinal College, Oxford (now Christ Church) and made plans for fifteen feeder colleges, with the main one in Ipswich. However, before the building of the college was completed, Wolsey fell from power and the building was abandoned.

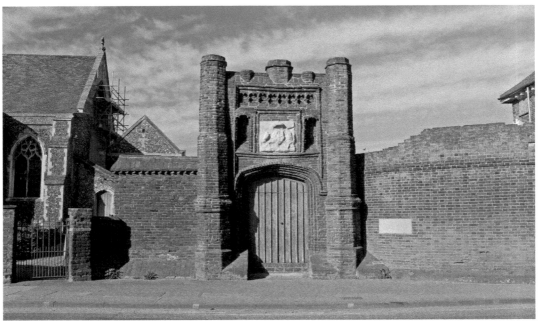

Wolsey's Gate and St Peter's Church

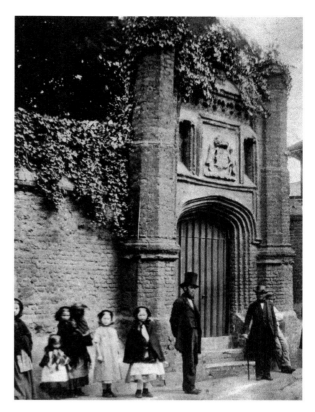

The gate was only ever supposed to be a side entrance for those arriving by river (the waterfront used to be much closer to this site). Today, the gate stands by a busy road, the pollution from which is slowly eroding the crest of Henry VIII, whom Wolsey served. After his fall from power, Wolsey died on his way to face charges of treason in London and was buried in an unmarked and unknown grave at Leicester Abbey. St Peter's church, visible in the background of the modern photograph, was to become the chapel for Wolsey's college. The impressively rare twelfth-century font, still to be found in St Peter's church, retains a Tudor base commissioned by the cardinal.

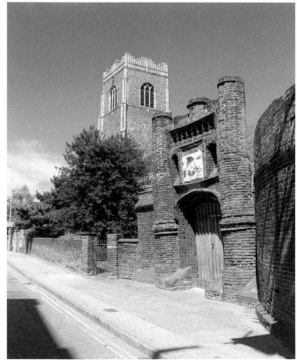

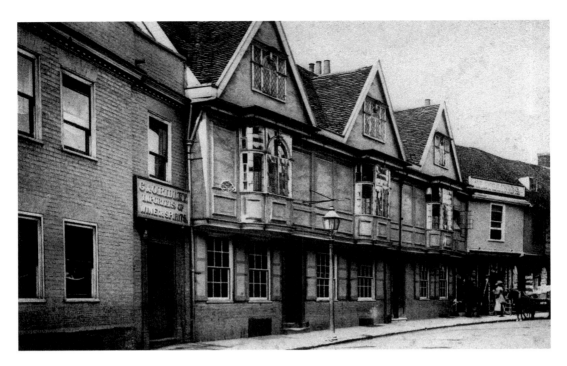

Old Merchant House

This is one of many merchant houses that abounded in Fore Street centuries ago. Many of these buildings date back to at least the seventeenth century. These houses would often incorporate living quarters, a shop and warehouse. Today, this house is situated towards the north end of the street and has found a modern use as the offices of the recruitment consultants 'Find a Job', who have been recruiting in Ipswich and Suffolk for fifty years.

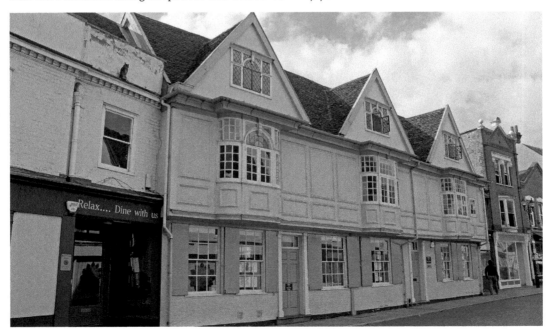

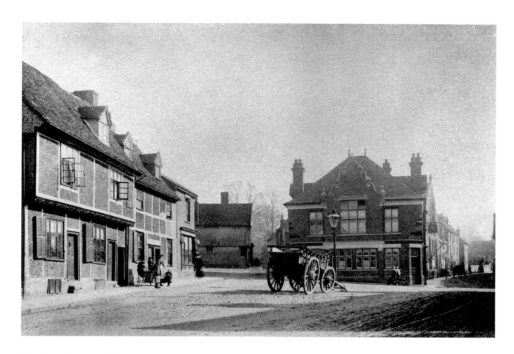

Back and Fore Hamlet

Above is the junction of Fore Hamlet and Back Hamlet, photographed in the 1870s. This spot has seen many changes, especially with the road system having been altered in various attempts to improve traffic flow. A roundabout was in place here until recently, when the junction reverted to more or less its original layout. The Earl Grey public house, which stood on the corner, was demolished in the 1950s.

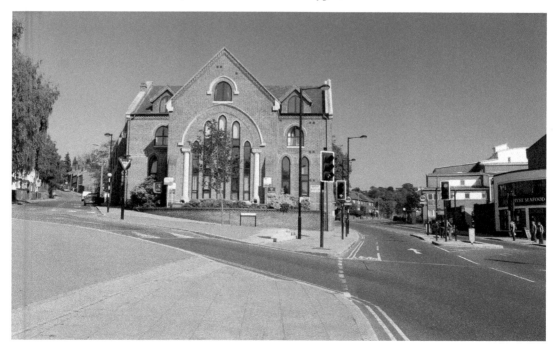

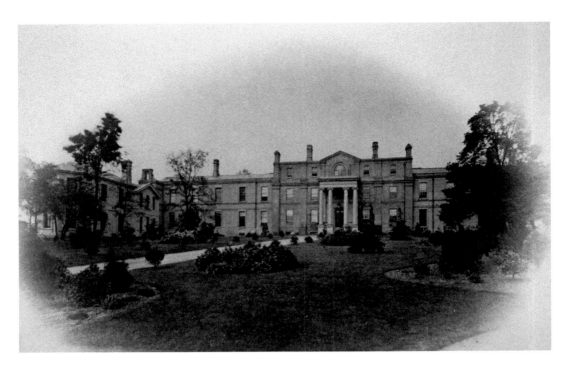

Ipswich and East Suffolk Hospital

This hospital was opened in 1836 and was constructed by public subscription. Originally it comprised of a single two-storey building but, over the years, a third floor and additional wings and structures were added. The buildings are currently used by the Anglesea Heights nursing home, with Ipswich Hospital on Heath Road now the town's principal medical care provider.

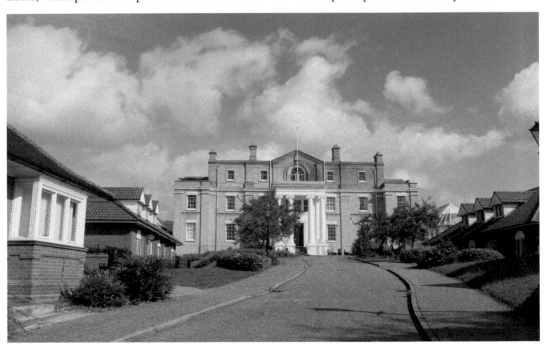

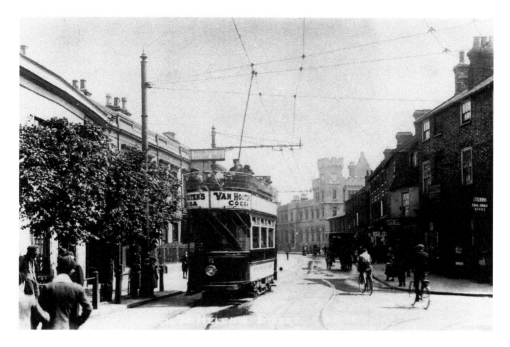

St Helen's Street

Above, one of the newly installed electric trams is seen operating in the early 1900s. The contemporary image shows one of the First Bus fleet that serves Ipswich today. In the background is the imposing building formerly used as County Hall. It is currently disused, but plans exist to convert it to a space for a registrar's office and wedding hall. There is a possibility that other parts of the complex may be used as a new space for the Suffolk Records Office. This is also where Wallis Simpson came to gain her divorce in 1936.

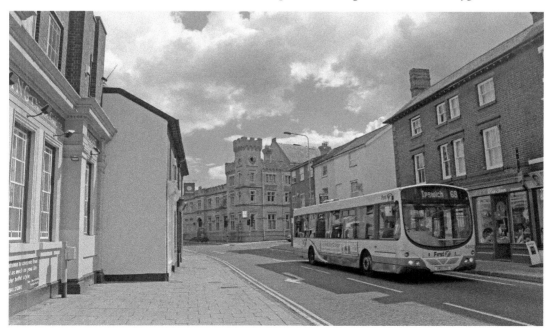

St Helen's Street, from Near St Helen's Church

This street is named after St Helen's church, the spire of which can just be seen to the top right of these photographs. The Regent also stands on this street, which has been used as a cine-variety hall, dance studio, music venue and theatre since opening in 1929. In modern times, this street has become busy with traffic as it is one of the main roads leading into the town centre from the east. The Dove Inn, dating back to at least the eighteenth century, can be seen in the background of both images.

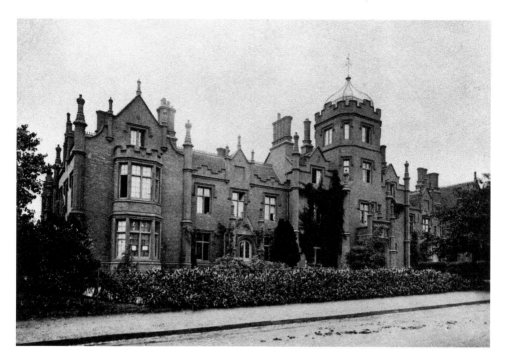

Grammar School

The roots of the Grammar School can be said to go back as far as the thirteenth century, albeit in different locations and buildings. At one point it was incorporated into the college set up by Wolsey, but managed to survive his fall from power and the failure of that venture. The foundation stone of the current structure on Henley Road was laid by Prince Albert in 1851.

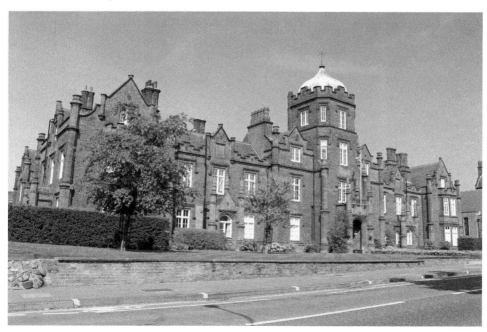

Industrial Ragged School

The Ragged School was founded in 1849 to help educate the poorer children of Ipswich. One of the school's founders and supporters was local philanthropist Richard Dykes Alexander, who was also an enthusiastic photographer and took some of the photographs featured in this book. The school's initial premises were on St Clement's Church Lane, but later moved to Waterworks Street (*see below*).

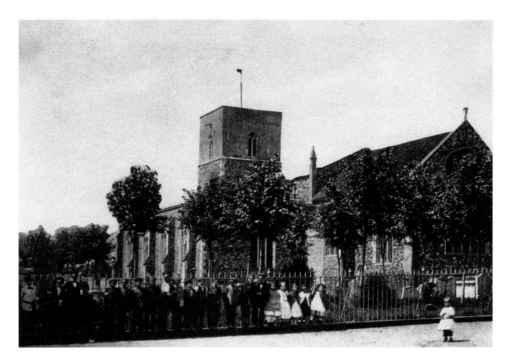

St Matthew's Church

St Matthew's is a medieval church dating back to the eleventh century, but was extensively renovated during Victorian times. In the nineteenth century it was known as the town's garrison church for its proximity to the town barracks. Above, the children of the Industrial Ragged School can be seen leaning against the fence. St Matthew's CE Primary School is now built on part of the old church cemetery.

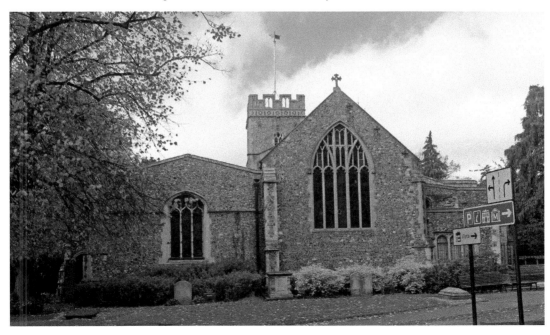

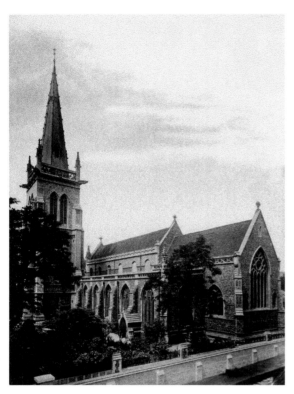

St Mary-le-Tower

St Mary-le-Tower was recorded in the *Little Domesday Book* (1086), and a church has stood here ever since. This is also the site at which the people of Ipswich gathered in 1200 to receive their town charter – one of the earliest royal town charters in English history. The tower itself wouldn't have been there at that time, as it is a Victorian addition to a church that has been much remodelled and rebuilt throughout its long history. It remains both a parish church with its own congregation and the Civic Church for the town of Ipswich.

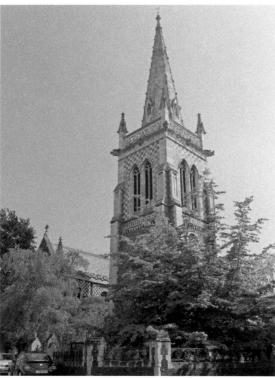

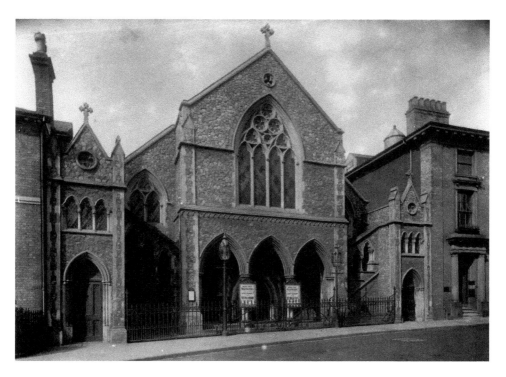

Museum Street Methodist Church

The foundation stone of this church was laid in 1860 by William Pretty, a successful businessman in the town. Methodism was a comparatively late arrival in Ipswich; however, the congregation continue to meet here and the church is still active in community life today, including playing host to guest speakers on topics such as local history.

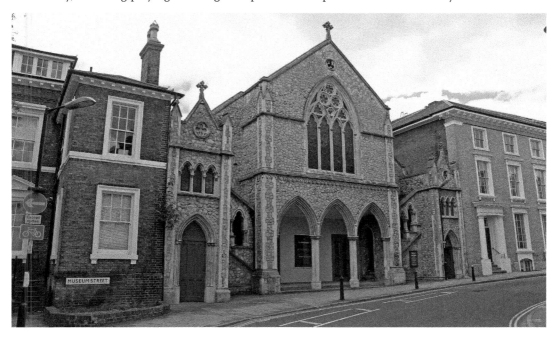

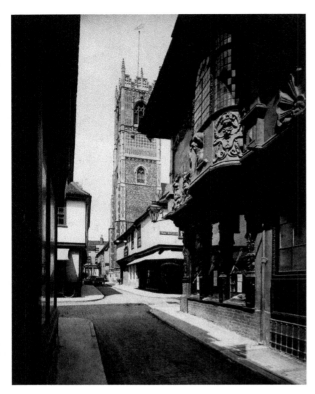

St Lawrence Church

The tower of St Lawrence was the tallest in Ipswich and the only one with bells from at least the 1440s to around 1500. The current 97-foot tower is the result of a Victorian rebuilding effort in 1882, but the bells that still ring today are originals dating from between 1440–90, making them the oldest ring of five church bells in the world. St Lawrence church was closed in 1974 at the same time as St Stephen's. Both of these churches have been looked after by the Ipswich Historic Churches Trust since it was set up in 1981.

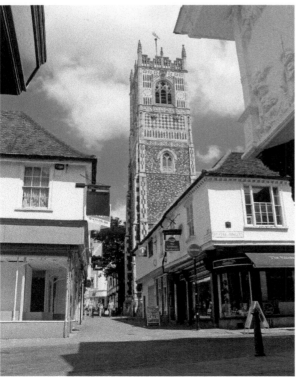

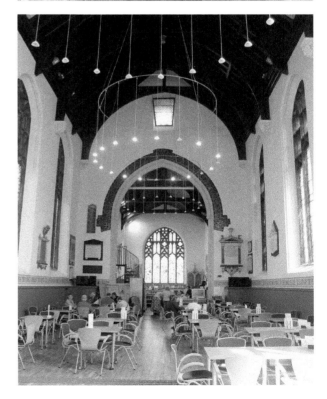

Interior of St Lawrence Church
Another of Ipswich's medieval churches, St Lawrence, dates back to the fifteenth century. Of the twelve medieval churches in Ipswich only St Lawrence and St Helen's have no aisles. The Beatitudes – from the gospels of Matthew and John – that run painted around the walls date back to the Victorian era, and can still be read today. In May 2008, the building reopened after thirty years of closure as the St Lawrence Centre and is now in use as a community centre, restaurant and gallery.

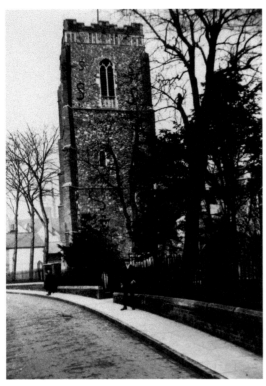

St Stephen's Church

This church now stands in Arras Square, named after Ipswich's twinned town in France, where, in turn, there is a Place d'Ipswich complete with a British red telephone box. A church of St Stephen is mentioned in the *Little Domesday Book* of 1086, although the current structure is less ancient than that; it was likely built on the same site during the fourteenth to sixteenth centuries. This medieval church, after being declared redundant in the 1970s, has found a successful new use as the town's tourist information centre.

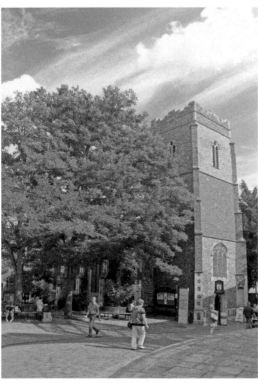

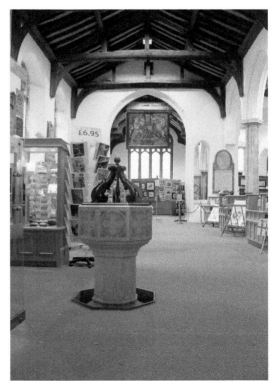

Interior of St Stephen's Church

The church was restored in 1994 after a long stretch of redundancy and retains much of its character while playing host to the books, guides, keepsakes and other wares of the tourist information centre. The interior houses many artistic treasures from Ipswich churches including paintings, memorials and monuments, as well as a collection of hatchments (centuries-old paintings on board that were hung as memorials for affluent men and women). St Stephen's is in many ways the most successful and sustainable of attempts to find new uses for Ipswich's historic churches.

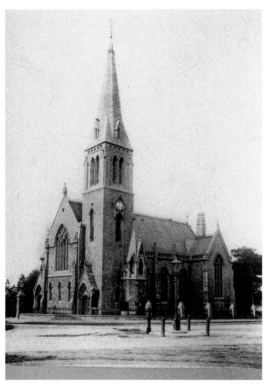

Presbyterian Church

The church was erected in 1870 and paid for by subscription. Money was collected from the congregation, who previously worshipped in a lecture hall in the town, and through contributions from around the country. Although the congregation has changed, the building is still used as a place of worship today by the Ipswich International Church. In the past, when personal time-keeping equipment was less readily available, the church clock was illuminated at night, at public expense, as a service to all the townspeople.

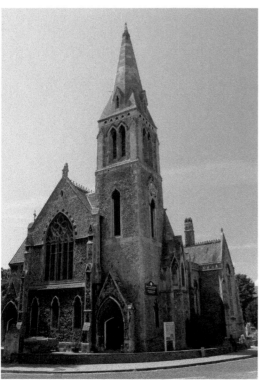

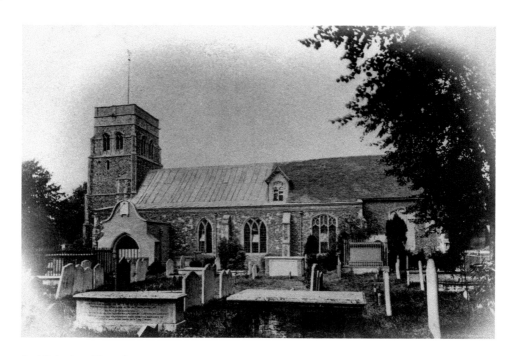

St Nicholas Church

St Nicholas is another of Ipswich's medieval churches, built in the fourteenth century. This was the church that the young Thomas Wolsey would have been brought to by his parents, who are buried in the graveyard. For some twenty years, the church stood empty, but in 2001 it was re-acquired by the Church of England and converted into a resource and conference centre for the diocese of St Edmundsbury and Ipswich.

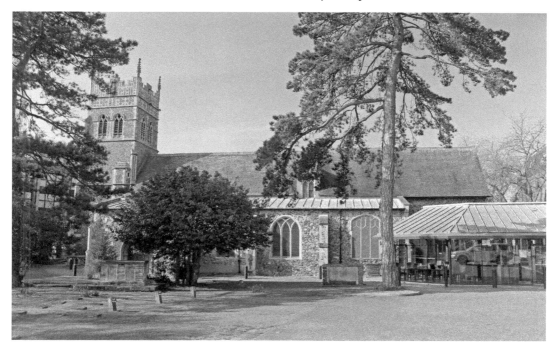

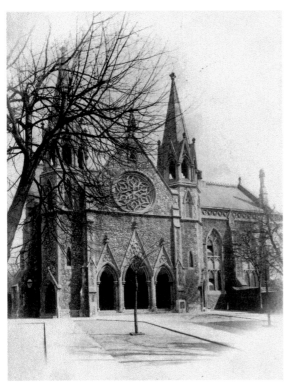

Tacket Street Chapel

The Tacket Street chapel was built in 1858 in just eight months. However, the history of this congregation can be traced back, long before this Gothic Revival style building, to the 1680s. This church is particularly notable for being the first in Ipswich to run a Sunday school in 1801. The two spires that are now missing were removed in the 1960s when they were considered to be unsafe. Now named Christ Church, it remains a place of worship and community today.

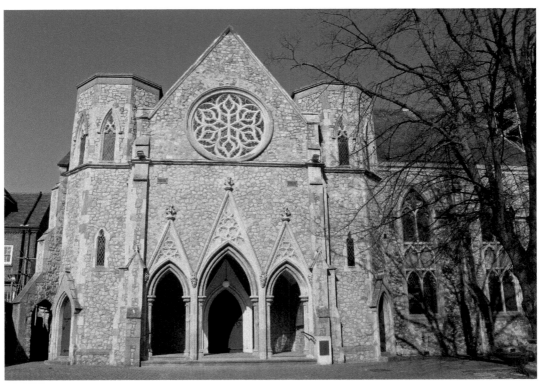

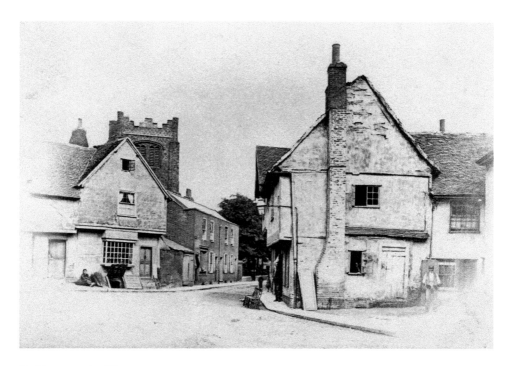

St Mary at the Elms

In Victorian times, the area surrounding this church was one of the poorest in Ipswich. The residents were mostly made up of the labouring classes, who lived in ramshackle cottages such as those seen in the foreground above. Though the red-bricked church tower, constructed in the 1440s, could once be seen peeking over the tops of these cottages, St Mary's now stands in relative open space.

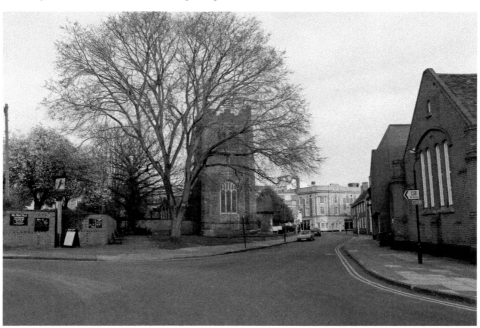

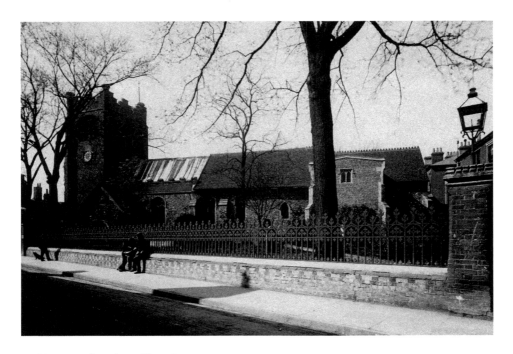

St Mary at the Elms Church

This attractive church acquired its name from the trees in its churchyard. St Mary at the Elms was rebuilt on the site of an older church dedicated to St Saviour. The stone doorway in the south porch likely dates to Norman times. Henry VIII visited St Mary's and the shrine of Our Lady of Grace. During the Reformation, it is thought that the shrine was smuggled out of the country and now resides in Italy – a replica has been placed at St Mary's and is visited annually by the people of Nettuno, Italy.

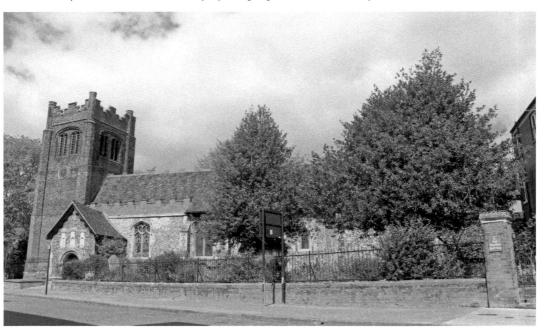

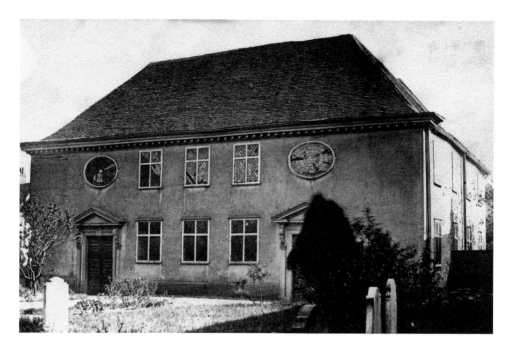

Unitarian Meeting House

The Unitarian Meeting House is the oldest surviving timber-framed chapel in East Anglia. This Grade I listed building owes its existence to the religious turmoil of the seventeenth century when many new Christian groups emerged. The Act of Tolerance of 1689 encouraged these groups to create their own places of worship, sometimes in converted houses or in new purpose-built buildings, as in this case. It now neighbours another Grade I listed building, one of the country's youngest, and Norman Foster's first major commission, the Willis Building.

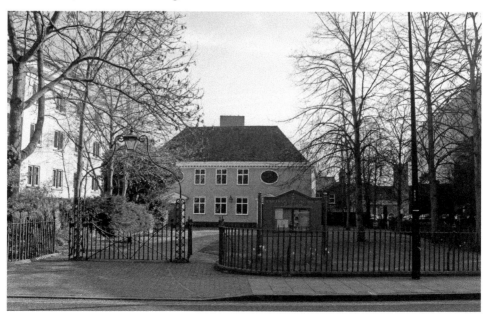

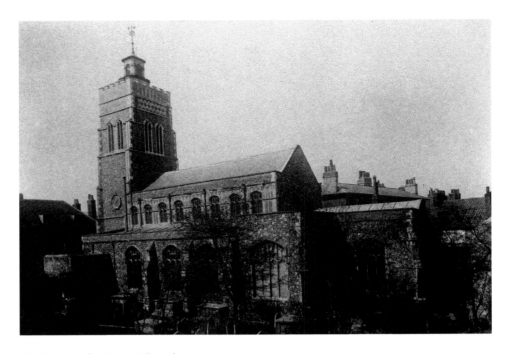

St Mary-at-the-Quay Church

This is another of Ipswich's medieval docklands churches that served the maritime town. The construction of St Mary-at-the-Quay began in the fifteenth century. The church sustained damage during the Second World War when a bomb fell east of the site in 1943. The building is currently undergoing renovation by the Churches Conservation Trust, which is working with Suffolk Mind to transform this long-neglected building into a Wellbeing Heritage Centre, hopefully securing a long-term future for St Mary-at-the-Quay.

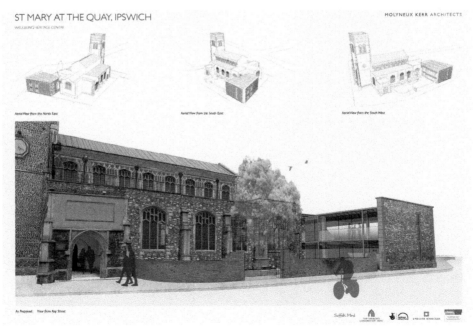

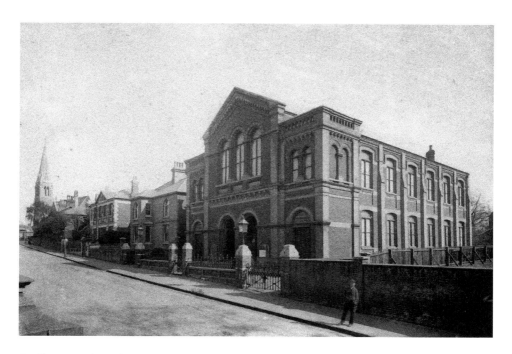

Burlington Chapel

When William Vick captured this Victorian photograph the structure in the foreground was known as Burlington chapel. This mid-nineteenth-century building is today called Burlington Baptist church and is a Grade II listed structure. A congregation continue to use the space for worship and community events. A new glass-fronted building compliments the church, but in general London Road appears little changed from this view. The spire of what is now the Ipswich International church can be seen to the left of both images.

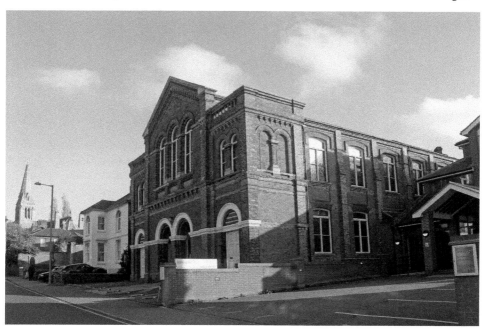

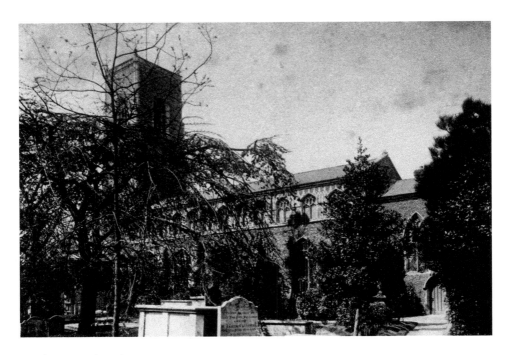

St Clement Church

Secreted away behind its surrounding foliage, this church is something of a hidden gem. In times past known as the Sailors' church, it had many prestigious congregation members – Sir Thomas Slade, designer of HMS *Victory*, is buried in the churchyard. The church was declared redundant in the 1970s and since then been largely disused, apart from a spell as a prop store for the Wolsey Theatre. There is hope for the church coming back into use as plans are progressing to transform it into an arts centre.

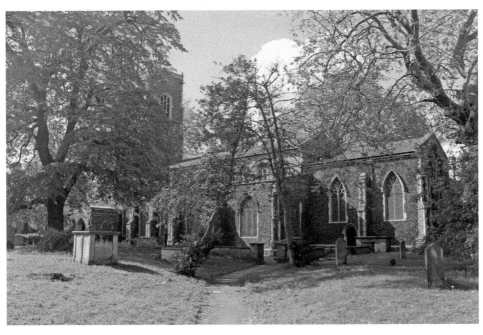

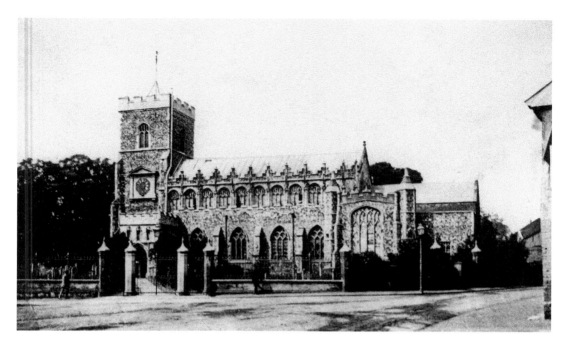

St Margaret's Church

Considered by many to have the finest exterior of any church in the town, St Margaret's was built around 1300 by an Augustinian Priory for the use of the expanding town. St Margaret's remained the most populous parish well into the nineteenth century. Changes made to the tower as the result of a Victorian expansion can be seen clearly by comparing the photograph above, taken in 1865, and the church as it stands today.

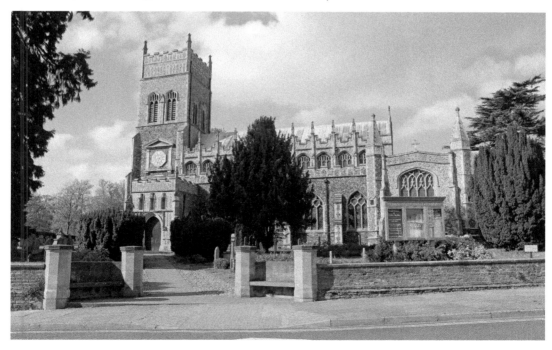

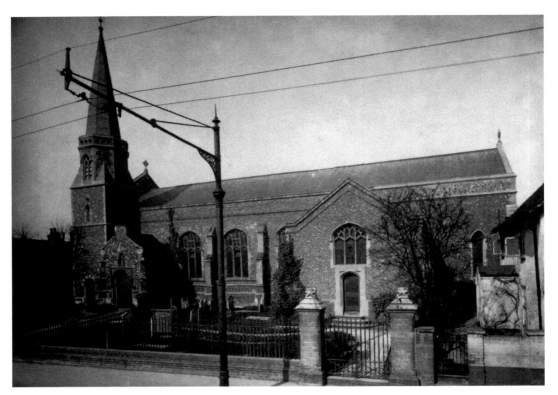

St Helen's Church

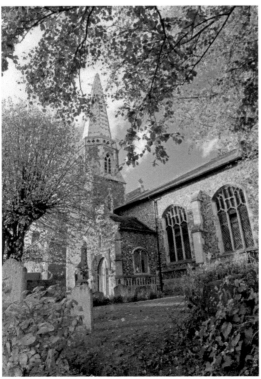

A church dedicated to St Helen has stood upon this site for around 900 years, although the structure has been so heavily modified over the centuries that little of that age survives. The church was extensively redeveloped in the 1830s, and the tower was replaced with the current one in 1875. It is situated a little way out of the town centre, and would have stood outside the town walls that once encircled the town. St Helen's remains a place of worship within the Church of England denomination.

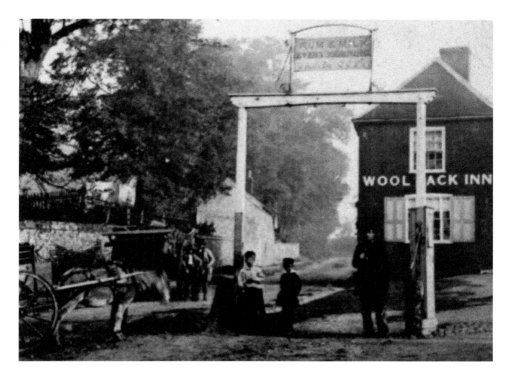

The Woolpack

The scene above was captured by Robert Burrows in 1858. The Woolpack, being as it was situated on the edge of town, was a good place to seek refreshment upon arriving at or leaving Ipswich. This is one of the town's most ancient pubs still in existence. The entertaining sign in Burrows' photograph, proclaiming 'rum & milk every morning' is, alas, no longer in place.

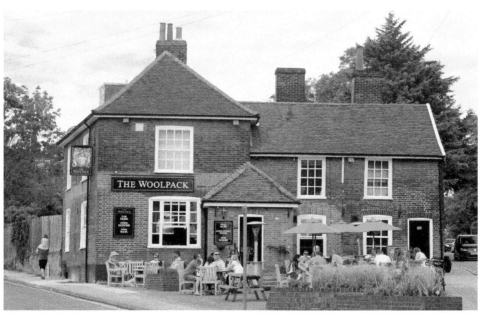

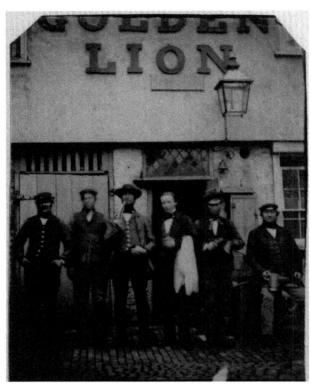

The Golden Lion

Another drinking establishment with a long heritage in Ipswich is the Golden Lion. In fact, along with Manning's next door, it is one of the two oldest buildings on Cornhill. The photograph above shows a group of servants outside the Golden Lion Hotel in the 1850s. The pub is still going strong under the same name, but is now part of the J. D. Wetherspoon chain.

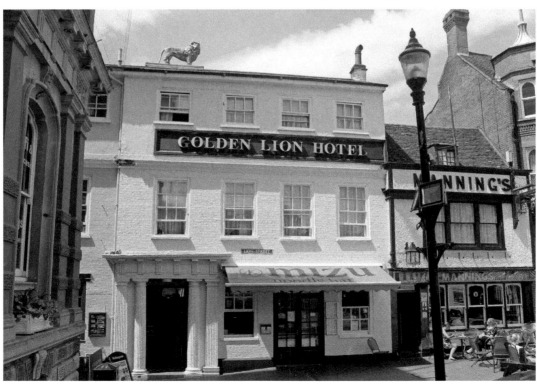

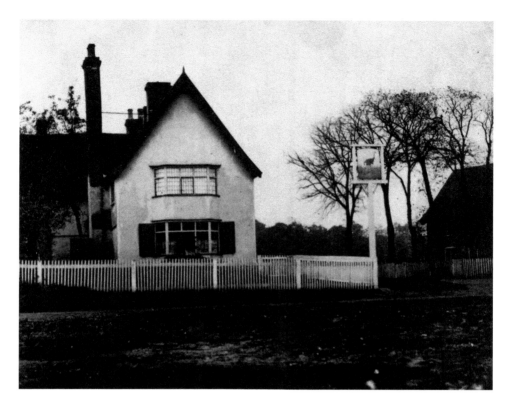

The Ostrich

This inn on the outskirts of Ipswich has expanded over the past century. Originally called the Ostrich, it was so named for the bird's depiction upon the crest of Sir Edward Coke, who owned the land where the building is situated. New owners took over during the 1990s, and the name was changed to the Oyster Reach, which appears to have been down to a misunderstanding that its name derived from the oyster layings in the River Orwell.

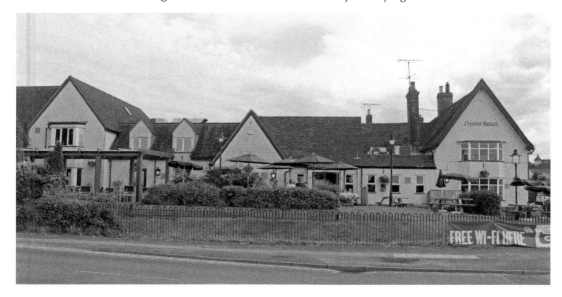

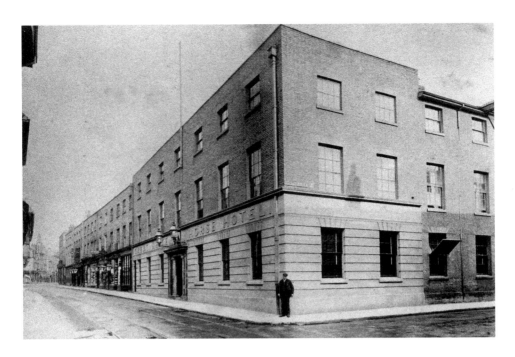

The Great White Horse

This former hotel is perhaps best known for featuring in the Charles Dickens novel *The Pickwick Papers*. Dickens visited the hotel himself, as did Lord Nelson in 1800 and George II in 1736, indicating the status of the Great White Horse as Ipswich's premium hotel in times past. The Great White Horse has recently been converted into shops, but the building retains its well-known façade and lettering.

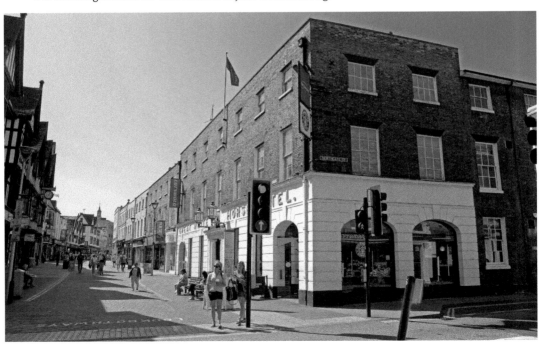

The Neptune Inn

Originally built in 1490 and extended in 1639, it is thought that the building was originally a merchant's house. However, for a large part of its history, the Neptune served as a pub (as shown above in this photograph taken in the late nineteenth century). Since 1937, the building has been used as both a workplace and a private house. The Neptune Inn sold pints to dock workers, but the Café Neptune (*to the left of the image below*) is today likely to be found selling tea and coffee to students from the nearby University Campus Suffolk.

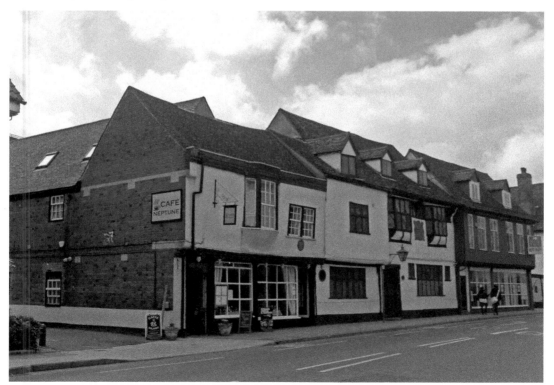

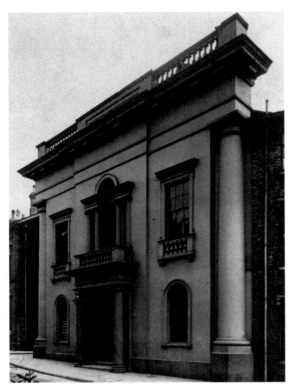

Museum on Museum Street, Exterior
This was the former premises of Ipswich Museum. The first brick was laid on 1 March 1847. After the collections were moved to a new museum on High Street in 1881, the building on Museum Street was used as a dance hall for many years. Today, it houses Arlingtons Brasserie, a restaurant and café bar. The building is now Grade II listed, and the exterior remains little changed to this day.

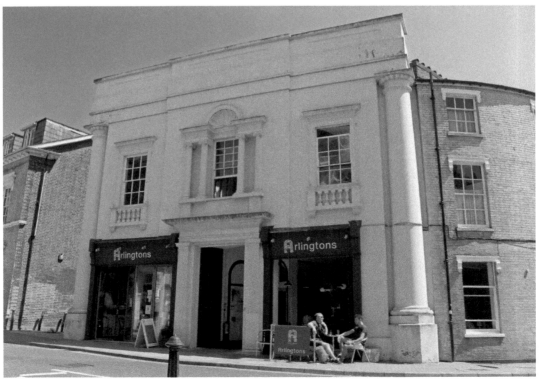

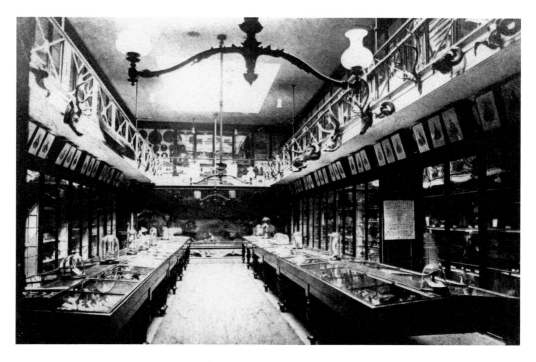

Museum on Museum Street, Interior

From early on, Ipswich Museum proved itself to be a prestigious institution, even garnering patronage from Prince Albert who, according to Queen Victoria, talked of scarcely anything else for several days after his return from a visit. The space has since been pleasantly converted into a restaurant and the natural history specimens replaced by fine food and diners.

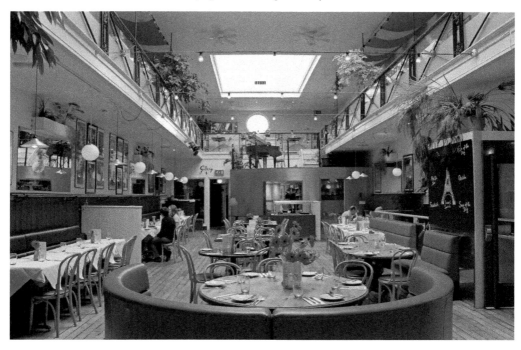

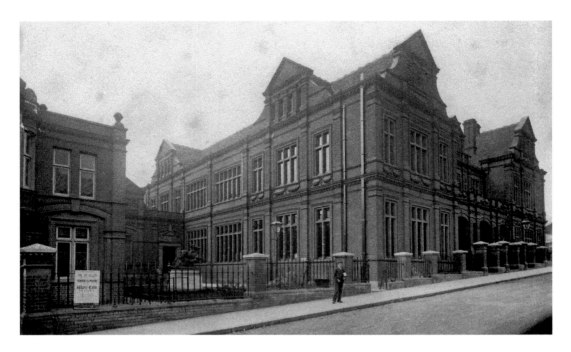

Museum on High Street, Exterior

The design for the new museum on High Street was thrown open to competition, and eventually this red-brick building with ornate terracotta panels was chosen. The new museum was greatly expanded to include a library and schools of science and art. In the Victorian era, it was one of the finest regional museums in the country. The railings in front of the museum, which have now been replaced with hedges, were taken for scrap to help the war effort in the 1940s.

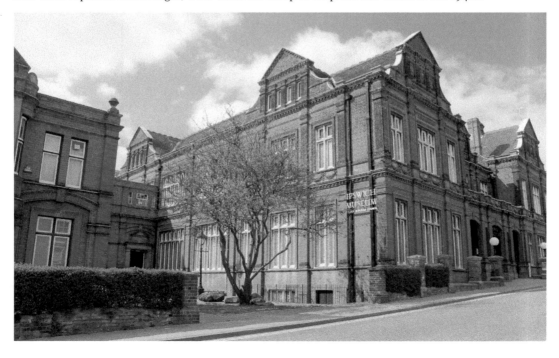

Museum on High Street, Natural History Gallery

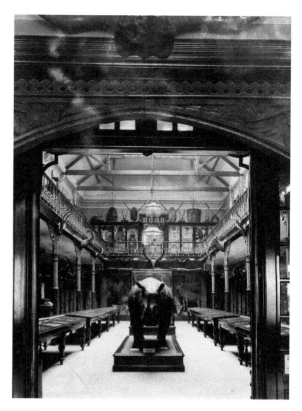

The design of the new central gallery in the High Street museum largely replicates the layout of the old museum. The collections have continued to grow; the museum now also has galleries featuring collections of geology, natural history and artefacts from Ancient Egypt, Anglo-Saxon East Anglia and ethnography, as well as displays telling the story of Ipswich. The aesthetic of the Victorian Natural History Gallery remains, with later striking additions such as the arrival of a taxidermy giraffe in 1909.

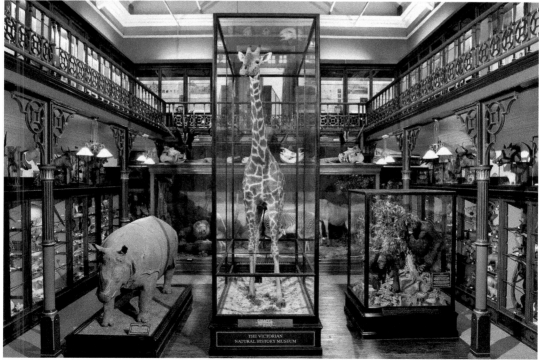

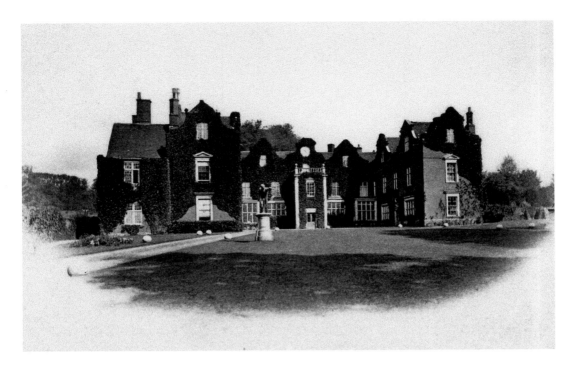

Christchurch Mansion

The history of Christchurch Mansion goes back as far as the 1540s when the Withypoll family began its construction on the site of the former Priory of Holy Trinity. The mansion and grounds in turn passed into the hands of the Devereux and then Fonnereau families. Felix Cobbold took possession of the building and generously presented it to the town in the 1890s. Christchurch Mansion opened as a museum soon after, and public admittance is free to this day.

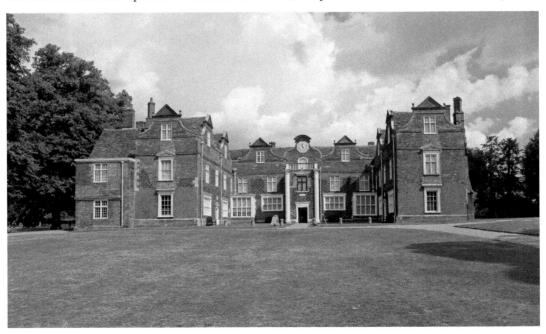

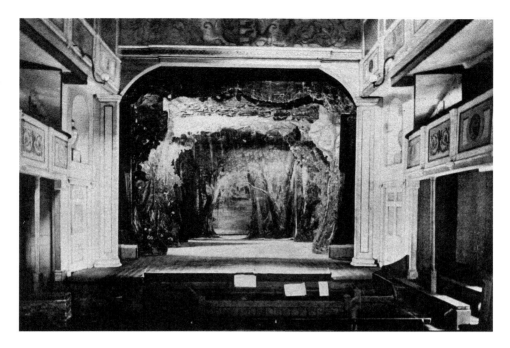

Tacket Street Theatre and New Wolsey Theatre

The Tacket Street Theatre (*pictured above*) dates from 1803. It saw many public favourites tread the boards throughout the nineteenth century, but closed around the time William Vick took this photograph in the 1890s. Contemporary Ipswich continues to have a rich theatrical presence – perhaps most prominently since the reopening of the New Wolsey Theatre in 2001, which has garnered respect nationally for the diversity of its performers and audiences, and its style of actor/musician productions.

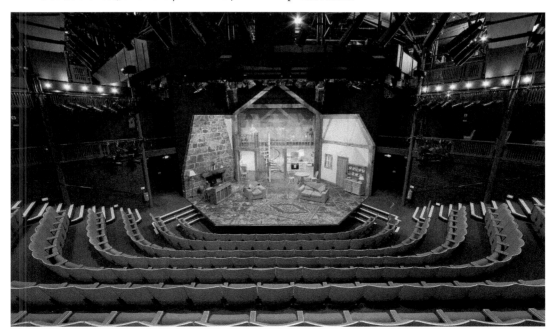

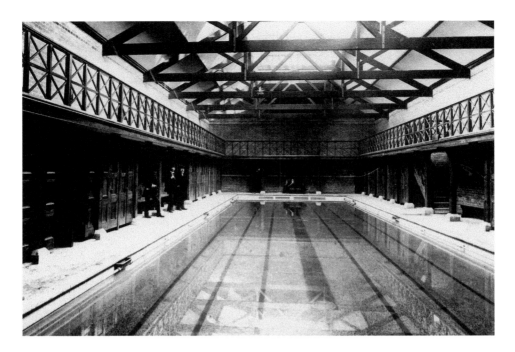

Swimming Bath

The Victorian Fore Street swimming bath, containing a 25 by 7-yard pool, was built in 1894 with money provided by Felix Cobbold – the same member of the Cobbold family to present Christchurch Mansion to the town. Although Crown Pools is now Ipswich's main central swimming pool and leisure centre, Fore Street Pool, as it is now known, is still open to the public and is run by Ipswich Borough Council.

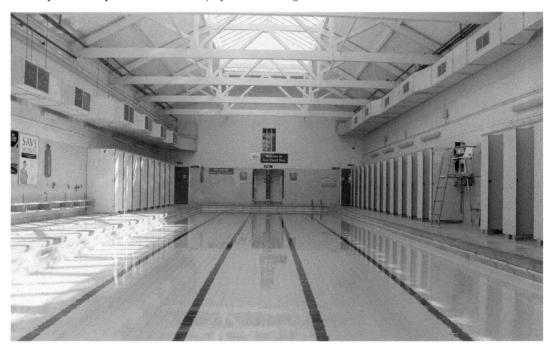

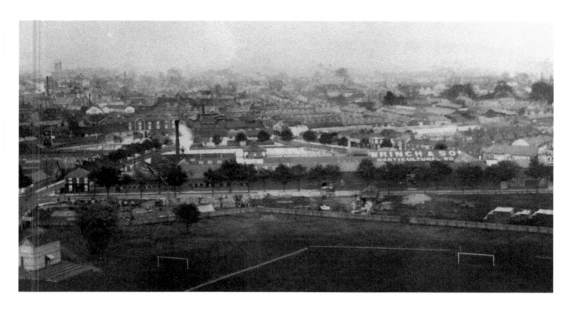

Portman Road Stadium

Ipswich Town FC was originally formed in 1878 as Ipswich Association Football Club. The club moved to their new home at Portman Road in 1888, at first sharing the ground with the already established rugby club. The view above was captured in 1902. They became a professional club in the 1930s. Ipswich Town were Football League champions in 1961/62 under Sir Alf Ramsey, and later won the FA and UEFA Cups under the management of Sir Bobby Robson. Today, Portman Road has a stadium capacity of over 30,000.

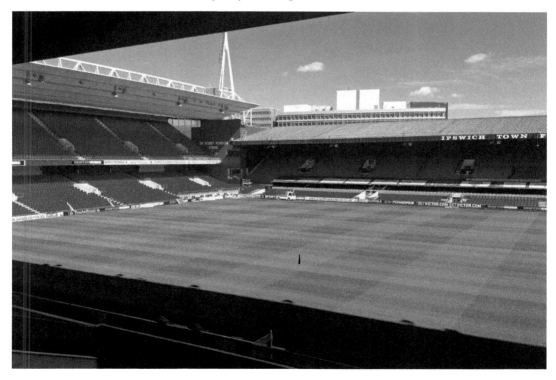

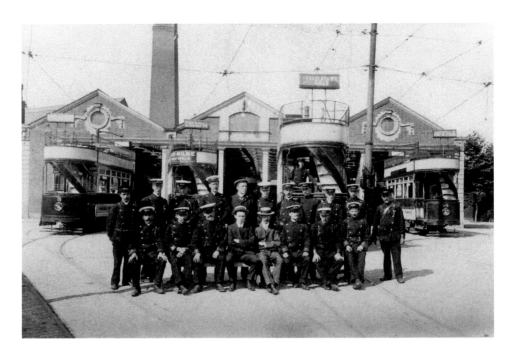

Tram Station

Horse trams were replaced with electric trams by the Ipswich Corporation from 23 November 1903. Soon, 17 miles of tram lines connected the town centre to the railway station and stretched into Ipswich's growing suburbs. The tram cars were sheltered here on Constantine Road in the large car sheds. These same shelters continue to be used by Ipswich Buses today.

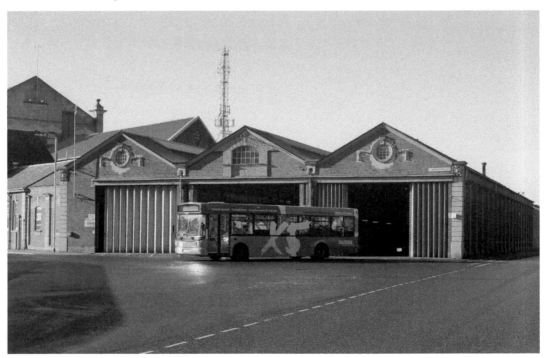

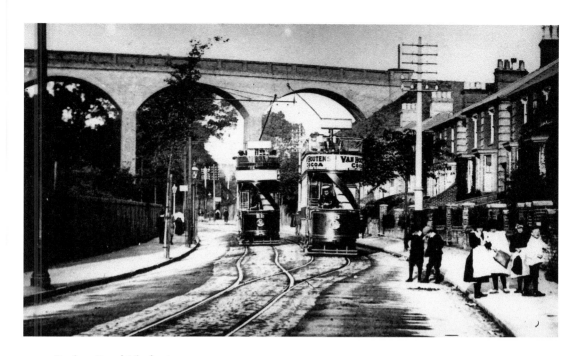

Spring Road Viaduct

Built in the 1870s, the three-arched Spring Road Viaduct allows the passage of the Felixstowe Branch line through the suburbs of Ipswich. Abellio Greater Anglia continues to run a passenger service on this line from Ipswich to Felixstowe. By the early twentieth century, Ipswich was well connected by public transport, particularly with the newly installed electric trams (*as seen above*). The removal of the tram lines and the car in the foreground of the modern photograph tell the story of how individualised transportation has subsequently become more predominant in the town.

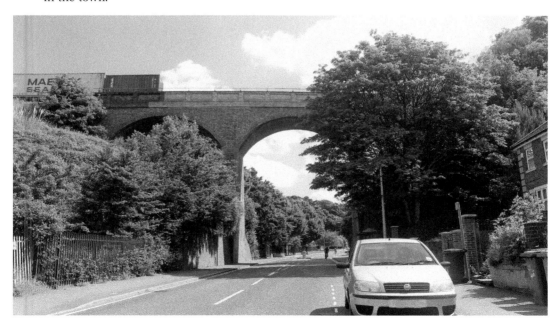

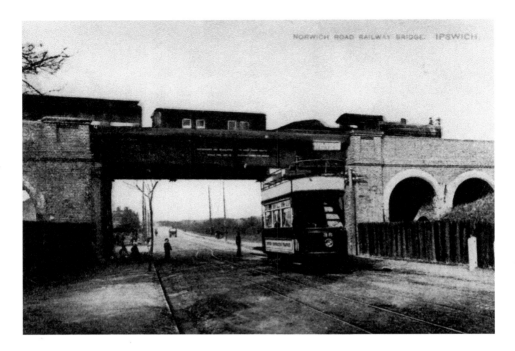

Norwich Road Railway Bridge

A message requesting that passengers keep their seats while the car is passing under the bridge was painted on the Norwich Road railway bridge, but is now sadly gone. This is a fitting reminder of how new this form of transport was in the early twentieth century when this photograph was taken. The open space beyond the bridge is now a built-up residential area, and the bridge's arches have now been bricked up.

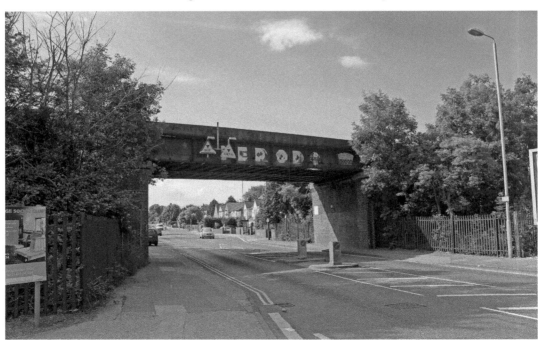

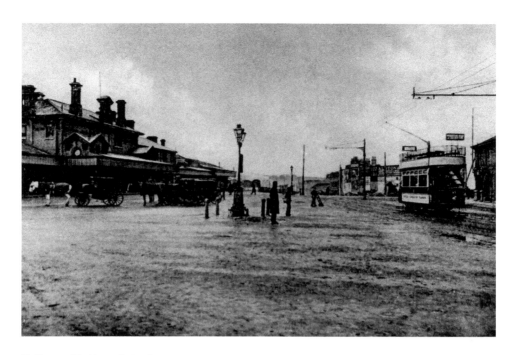

Railway Station, Exterior

The current railway station was opened in 1860, replacing the first station built in 1846. It is very evident from these photographs just how much transportation has changed in the intervening years. In the first decade of the twentieth century, horse-drawn transportation was still playing its part alongside the newly installed electric tram system in Ipswich. In the contemporary photograph, the car has clearly taken over.

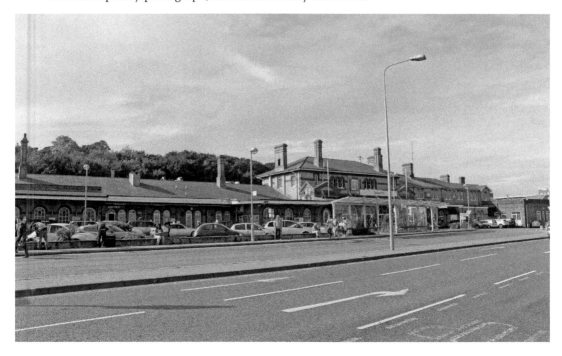

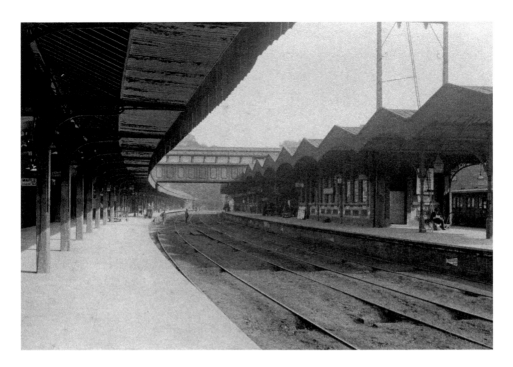

Railway Station, Interior

The railway station only had one platform when it first opened, but in 1883 the island on the right-hand side of these images was added. The track has since been electrified and, in more recent times, a second footbridge across to the island has been installed. It remains a busy station that now includes cafés and shops.

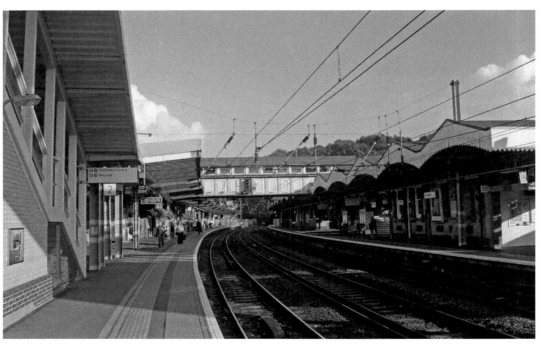

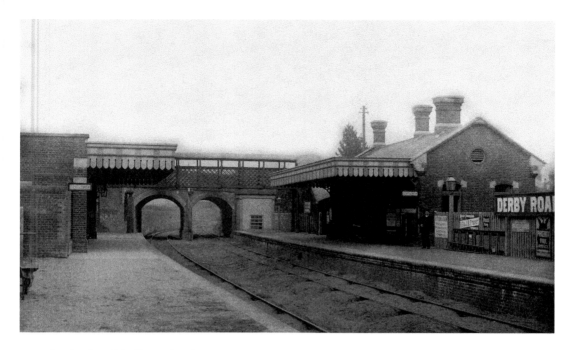

Derby Road Railway Station

Opened in 1877 by the Felixstowe Railway and Pier Company, Derby Road railway station still operates a passenger and freight service between Ipswich and Felixstowe. For a long time, the station was much used by people in the eastern suburbs of Ipswich, as catching a train from here, rather than from Ipswich central station, shortened the journey to Felixstowe by over 6 miles. The station remains in use today; however, Derby Road is now a relatively quiet and mostly unstaffed station.

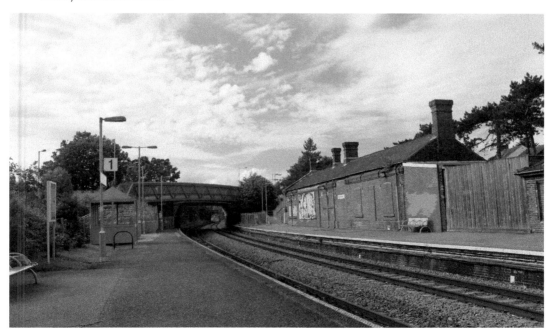

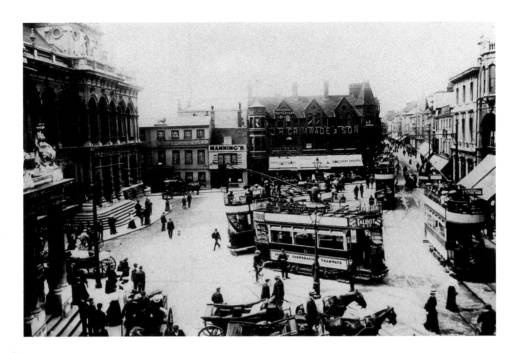

Electric Trams and Ipswich Transport Museum

The Ipswich Corporation Tramways Act of 1900 ushered in a new era of public transport in Ipswich, and soon put an end to horse-drawn travel. Thirty-six double-decker electric trams once served the town, but this was not to last long. Ipswich became the first town in the country to trade in trams for trolleybuses in 1926. The tramcars were sold for use as chicken coops and garden sheds. Below, one of the restored tramcars can be seen in Ipswich Transport Museum where it continues to be enjoyed by visitors.

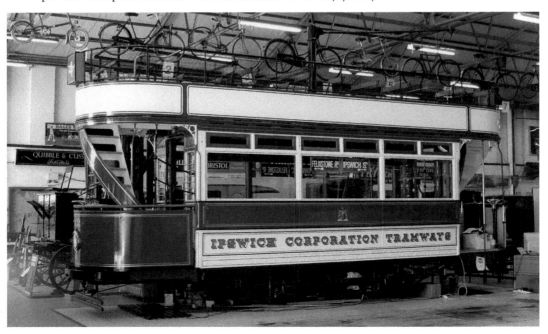

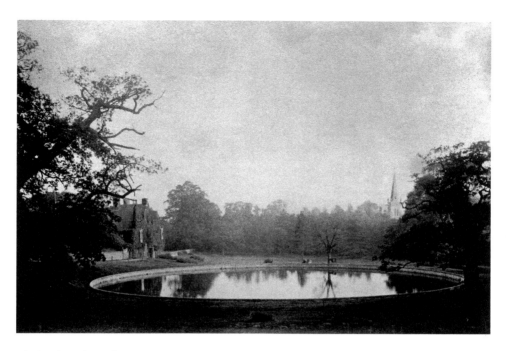

Christchurch Park

The spire of St Mary-le-Tower can be seen on the skyline, indicating how close to the centre of town the tranquil park grounds are. When William Vick took this photograph, the mansion and grounds were soon to come into civic ownership. Today, Christchurch Park is greatly treasured by the people of the town. It is here that Guy Fawkes Night is celebrated on a grand scale, and Ipswich Music Day, one of the biggest annual free music events in the country, is held.

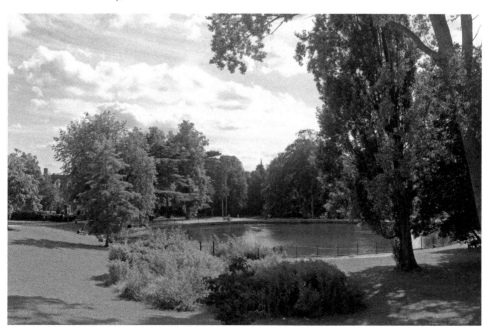

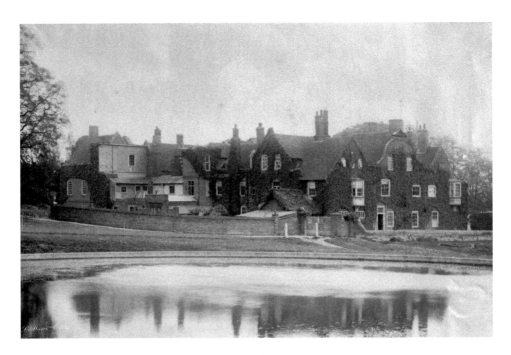

Christchurch Mansion from Over the Pond

Christchurch Park was accommodated within the grounds of the Priory of the Holy Trinity at one time. That all changed during the Dissolution of the monasteries under Henry VIII's reign, and it was then that the Withypoll family took over the land. The pond that still exists in the park is now colonised by ducks and swans, and is thought to have originally been used as the fish pond for the priory.

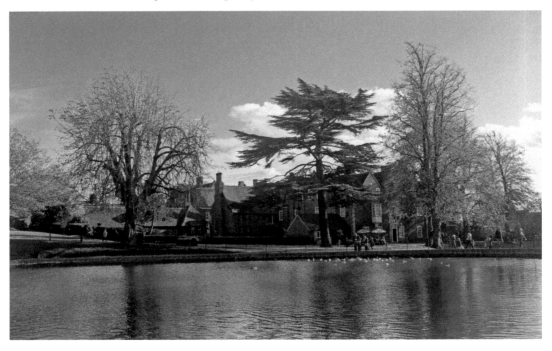

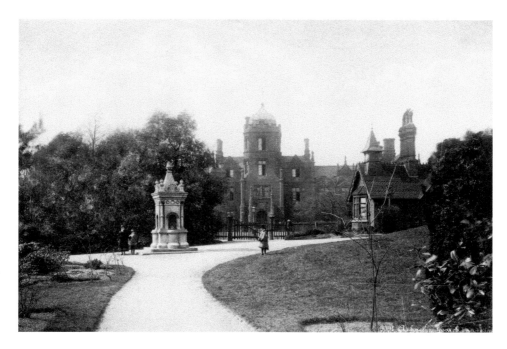

Arboretum

The arboretum has now been incorporated into the wider Christchurch Park, but long before the mansion and surrounding grounds came into civic ownership, the higher arboretum was freely open to the public. It was a popular retreat in the town, where people came to enjoy the immaculately landscaped space and gathered to watch games of tennis. The highly ornamented Italian style drinking fountain seen in these photographs was erected in 1862.

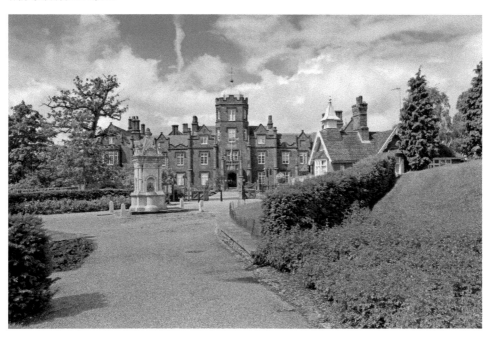

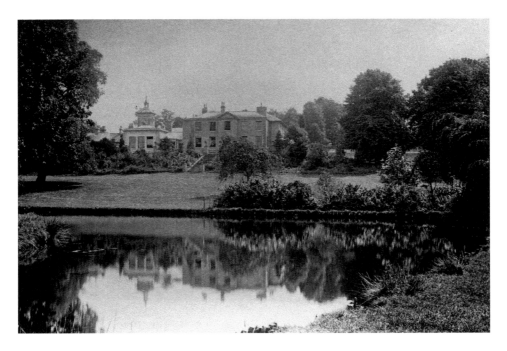

Holywells Park

This notable park incorporates 67 acres of grounds, ponds and woodland. It is said to have a history that goes back to possession by Queen Edith before the Norman Conquest. Holywells Park has subsequently been part of the estate of many influential families, including the Cobbold brewers who built the mansion (seen above in 1814), which has unfortunately since been demolished. A project is currently underway to restore and develop parts of the park, including the creation of an open-air theatre space.

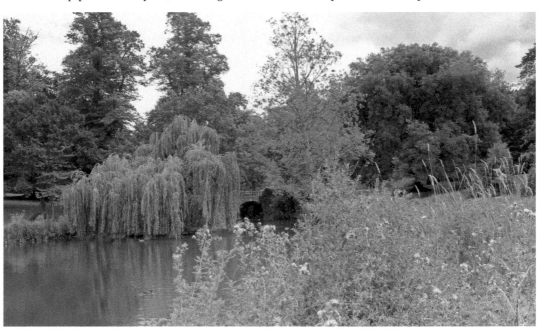

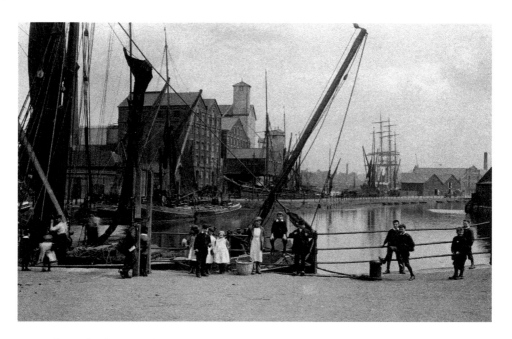

Ipswich Docks from Stoke Bridge

When the Wet Dock opened in 1842, it was the largest construction of its kind in Europe, and helped foster a renewed period of town expansion fuelled by a variety of dock related industries. The role of the waterfront has changed over the years, and some industrial buildings await regeneration. Currently, the docks are once again the site of large-scale construction in an effort to redevelop the space as a desirable place to learn, at University Campus Suffolk, and to live, in one of the many waterfront developments with picturesque views over the marina.

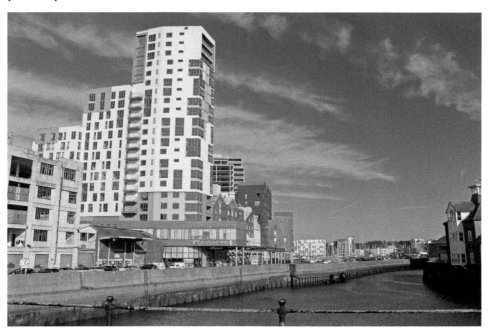

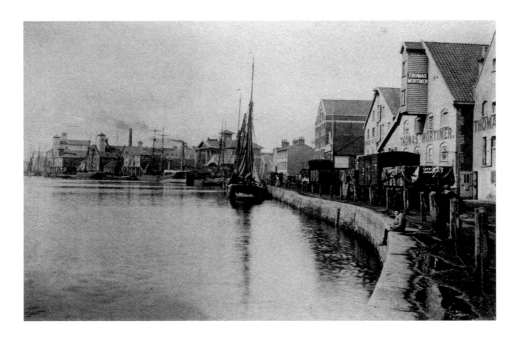

The Wet Dock

The Wet Dock is hardly recognisable when compared to its Victorian appearance. Even the Customs House, still much as it was, is masked in the photograph below by new developments. Much of this change in form has to do with the waterfront's change in function. Whereas the newly revitalised Wet Dock of the Victorian era was at the epicentre of Ipswich's trade economy, now it has largely been reimagined as a marina to relax in and enjoy. This is evidenced by the number of coffee shops and bars that have sprouted up by the water's edge in recent years.

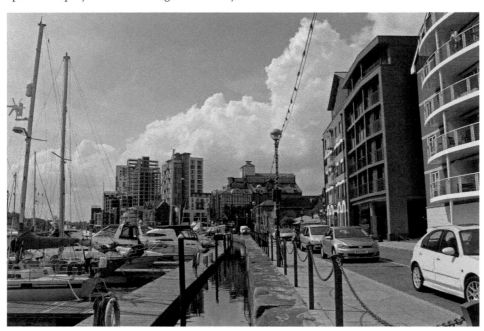

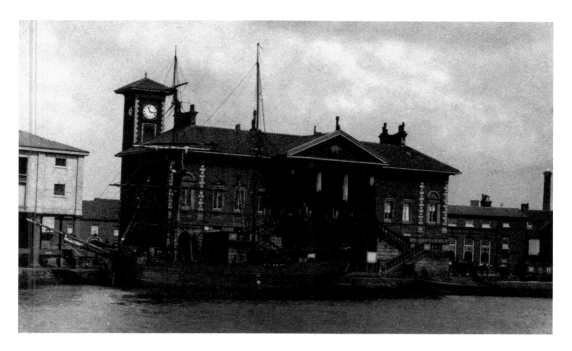

Customs House

This solid building was constructed in the 1840s as part of the renewal of Ipswich docks after a period of decline during the eighteenth century. It has played host to the Ipswich Dock Commission and the Ipswich Port Authority, as well as being partly used as a police station during its history. Today, the Customs House is part of Associated British Ports and still handles around 3 million tonnes of cargo each year.

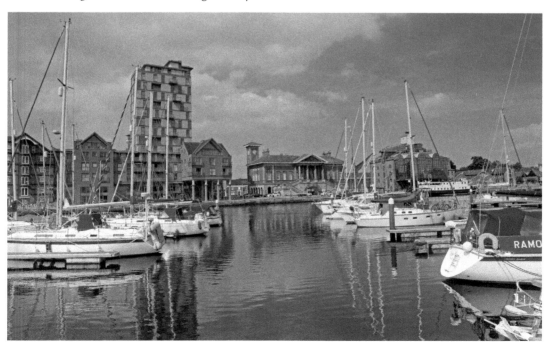

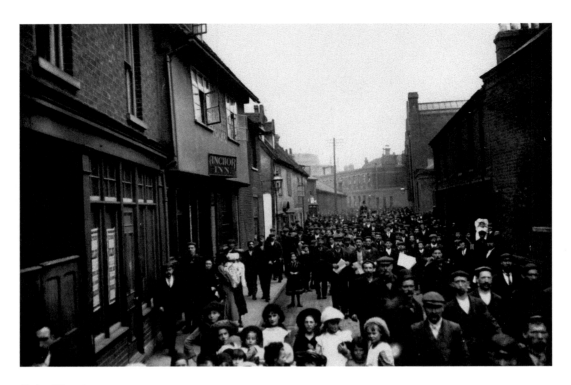

Duke Street

Duke Street was, for a long time, the place at which dock workers of all kinds would come to seek refreshment. The Anchor Inn (*above*) was fulfilling such a service from the first half of the 1800s, and was still clearly doing a brisk trade when this photograph was taken during an early twentieth-century dinnertime. Today, students are more likely to be seen drinking a quick pint over lunch in the area, as the road borders many of the new University Campus Suffolk buildings.

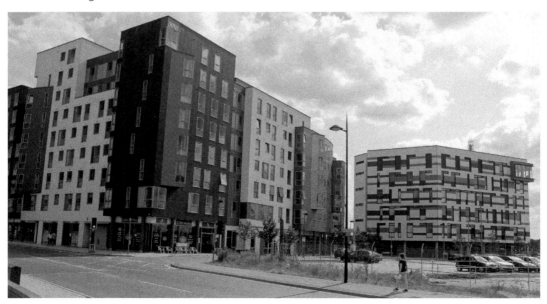

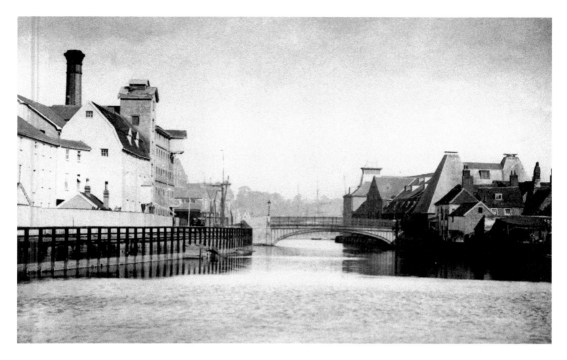

Stoke Bridge

This photograph, captured around 1890, shows just how much this area of Ipswich has changed over the past century or so compared to the image below. The bridge itself was rebuilt with concrete in the 1920s, and expanded to accommodate the increasing flow of traffic in the early 1980s. To the left is part of the Old Stoke Mill, which has now been replaced with an accommodation development called The Mill – currently Ipswich's tallest building.

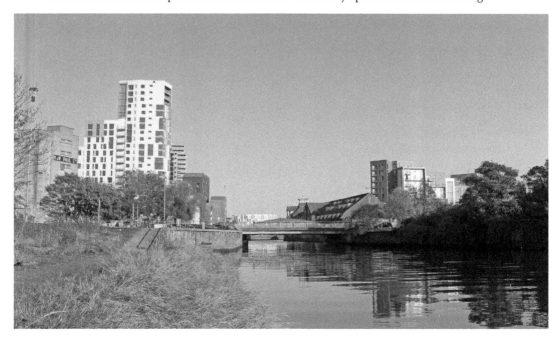

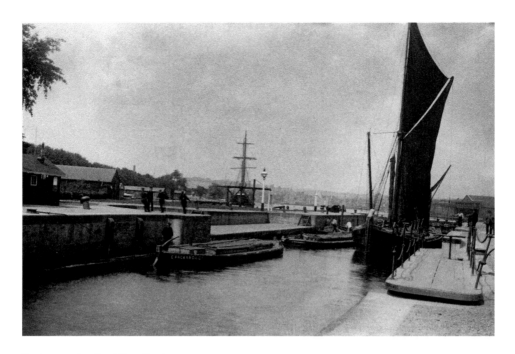

Entrance to the Wet Dock

The new lock gate was opened on 27 July 1881, the same day that the post office on Cornhill and the new museum were opened. The lock gate allows a constant water level within the Wet Dock by controlling access to and from the rising and falling tides of the river. The implementation of this principle greatly contributed to Ipswich being a successful Victorian trading port. Many changes have taken place regarding the function of the docks over the past century, but this same system of water level regulation is still employed.

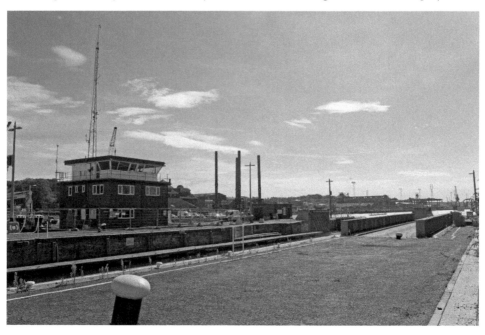

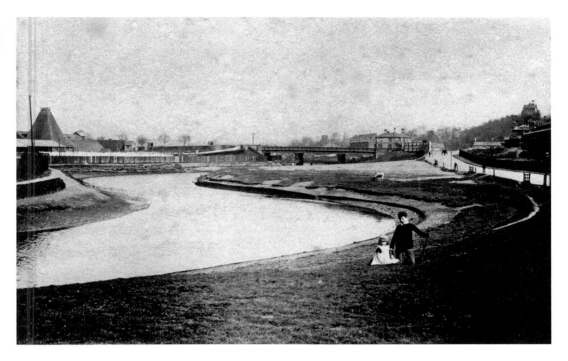

The River Gipping Near the Railway Station

Here, the River Gipping can be seen curving its way through Ipswich on its way to become the River Orwell. In the late 1800s, the train station (just about visible on the far right of the image above) was on the outskirts of Ipswich, but now the area is heavily built up. The Station Hotel by the bridge is still open for business, but is now obscured from this angle by new housing developments by the river.

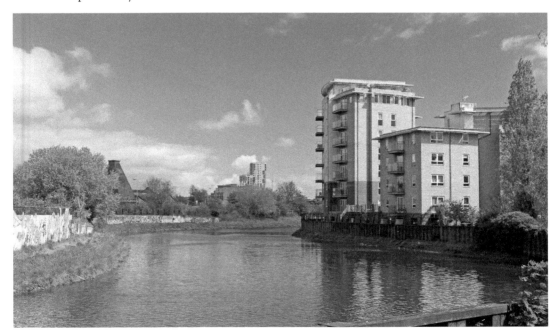

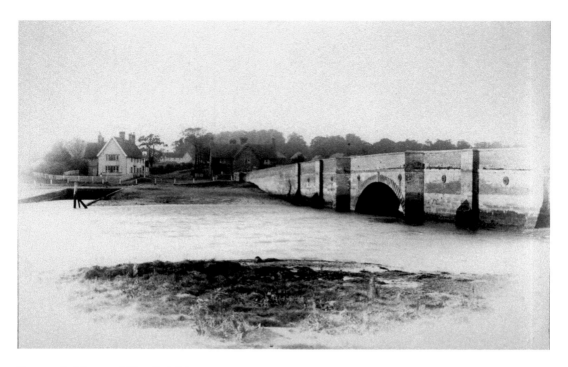

Bourne Bridge and The Ostrich

The Oyster Reach on the other side of the river was known in the past as The Ostrich. The site has clearly been much developed in the intervening years. Bourne Bridge remains in place, but only as a footbridge having been superseded by the newer and larger neighbouring traffic bridge. The spot from which both the photographs were shot is now part of the boatyard of Fox's Mariner, which opened in 1927.

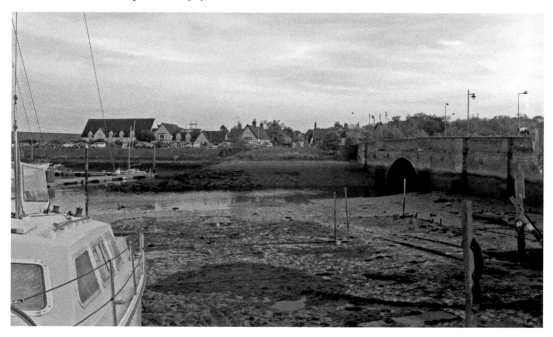

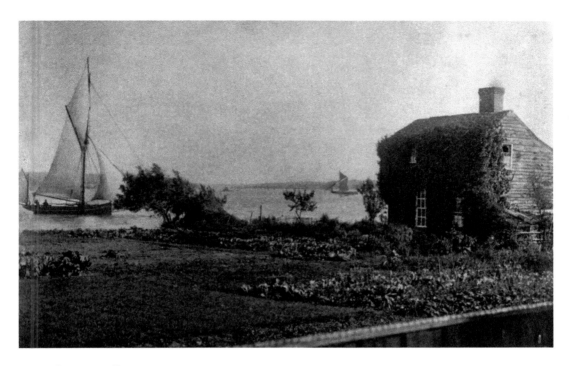

River Orwell

This Victorian photograph shows a picturesque cottage nestling by the shores of the River Orwell, a short distance from the town centre, by Wherstead Road. Despite extensive growth in Ipswich since then, the river nearby has retained some peaceful pockets (*as shown in the photograph below*), which is taken slightly further down the shore from the first. The predominant structure seen here is the Orwell Bridge, which was completed in 1982.

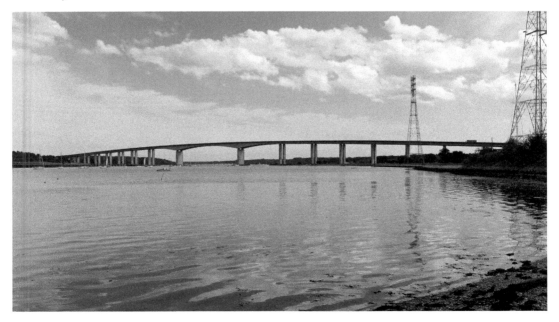

Gainsborough's Lane

In William Vick's photograph-book of the 1890s, next to his photograph of Gainsborough's Lane, he laments that the colours of nature at this spot cannot be caught and reproduced by any process. Although colour photography has gone someway to remedying this, Vick's pronouncement that it should be seen to be fully appreciated still holds true. This winding country path by the River Orwell, often painted by Thomas Gainsborough, including in his work *The Market Cart*, is still enjoyed by dog walkers and ramblers today.

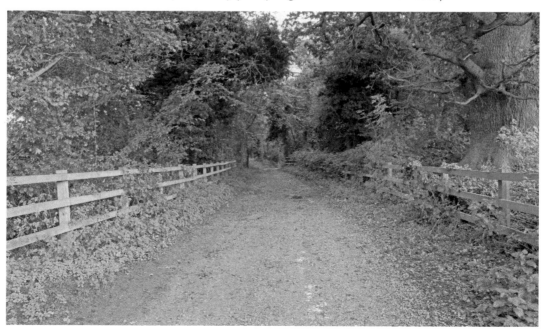

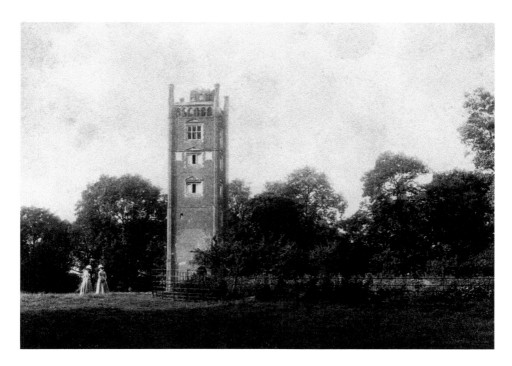

Freston Tower

This impressive structure is thought to have been built in the late sixteenth century by an Ipswich trader named Thomas Gooding. The tower still stands now, set in beautiful countryside just south of Ipswich by the banks of the River Orwell. Today, the six-storey tower is owned by the Landmark Trust and is enjoyed by holidaymakers.

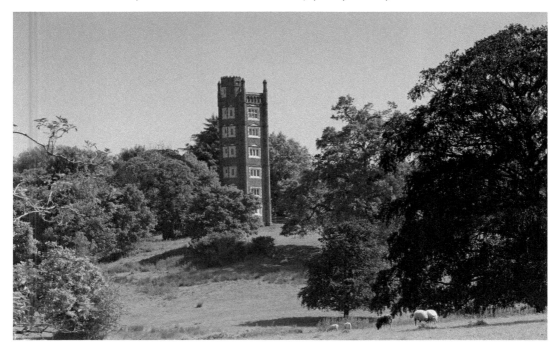

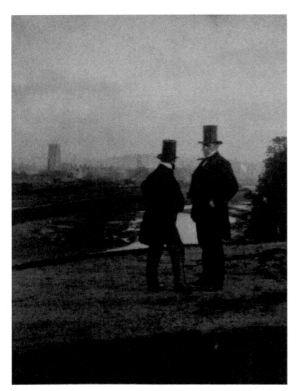

View of Ipswich from Over the River
This view over the river as it gently curves its way towards the docks shows Ipswich's development over the past 150 years. You can pick out the ancient St Peter's church, the industrial era encapsulated by the R. & W. Paul building and, with the Mill and UCS building in the distance, the modern reinvention of the waterfront as a place to live and study. This can all be found along the river which, over one-and-a-half thousand years ago, singled out this spot as a place for the earliest inhabitants of the town to settle.

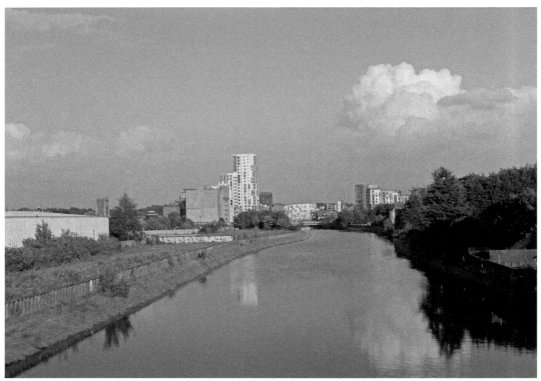